ROBERT A. GEAKE

COLONIAL
NEW ENGLAND
CURIOSITIES

Remarkable
OCCURRENCES,
MIRACLES &
MADNESS

for Zachary,
with best
wishes —

Charleston **H** London

THE
History
PRESS

To Zachary
from
Aunt Helen
2014

Published by The History Press
Charleston, SC 29403
www.historypress.net

Copyright © 2014 by Robert A. Geake
All rights reserved

First published 2014

Manufactured in the United States

ISBN 978.1.62619.642.1

Library of Congress CIP data applied for.

CONTENTS

ACKNOWLEDGEMENTS

I wish to thank all those who have helped in the research, editing and advising during the time this book came together. These include the staff of the John Carter Brown Library, as well as the Providence Athenaeum, especially Kate Woodehouse, the collections librarian. I would also like to thank Betsy Cazden and Dr. Patrick Conley for their reading and counsel on specific chapters of the book, as well as Ed Achorn of the *Providence Journal*, who published an excerpt from the book in the newspaper's fine commentary pages. I want to thank also Tabitha Dulla and Darcy Mahan of The History Press. Other friends, especially associates at the John Carter Brown Library, offered advice and recommended reading that was extremely helpful, and as always, I wish to thank my wife, Cyndie, for her reviewing and editing skills, which have always enabled me to offer the best possible book to my readers.

INTRODUCTION

*T*his book sets out to explore the everyday struggles that individuals encountered in the founding of New England. Much of these struggles were unforeseen. Certainly this was the case with the weather on North America's rugged coast, which was more extreme than what they had lived through in England, and the natural phenomena of the northern lights, the prevalence of lightning storms in the heat of summer, massive snowfalls in winter and sudden earthquakes caused great alarm.

So, too, did the wild creatures that inhabited the seemingly endless forests, as well as the remaining Native Americans, whose numbers were unknown, though settlers quickly learned of the plagues that had taken a great many of their people. In the wilderness, the specter of illness loomed also over the settlers, as there were few physicians and treatments for the recurring epidemics that plagued early New England's growth. In the midst of these natural obstacles, those in the colonies faced living under ever increasingly authoritarian government officials, whose law was the word of God, as they interpreted it. Such strictures within largely secular communities could only bring lawlessness to the fore, and such was the case in much of New England. In short, the first one hundred years of settlement were often dark and desperate times for those who had come to make a new life for themselves in America.

But while I researched the many struggles they faced, I came to learn also of an increasing resilience on the part of the settlers, as third- and fourth-generation families began to see the fruits of their own, as well as their

ancestors', labor. It was this generation that would proceed with an iron will to shape a civil landscape for future generations. I learned of the impact that the first religious upheaval in the colonies would have on individuals as well as on communities. For some, the Great Awakening would renew their faith in charitable work, while for others, it would profoundly change their lives to a greater calling as leaders in their communities or the colonies in which they lived.

As much as possible, I have let the journals, diaries and letters of those who recorded both day-to-day events and "remarkable occurrences" speak for themselves. They tell, after all, a more compelling account than any historian could muster.

AN UNSETTLED LAND

*N*ew England was a haunted land before the first European settlers arrived in the early 1600s. Native American trading relations with visitors from the northernmost reaches of the continent along the Charles and Taunton Rivers, as well as Mount Hope Bay, had occurred as far back as the fourteenth century. Trading with the Dutch, French and the English along Narragansett and Massachusetts Bay had occurred for nearly a century before those religious refugees from England rowed ashore. Some early traders had stayed, integrated themselves and even married into the Algonquian tribes that lived along the New England coastlines and inland along the rivers.

By the time of the Pilgrims' arrival in 1620, many tribes were already acquainted with household wares, the pots and pans and utensils brought by European traders, along with tools and even clothing. These goods were exchanged for beaver and, to a lesser extent, other animal pelts, as well as pottery in the form of dishes and bowls and clay pipes of easy manufacture by Narragansett, Massachusetts and Wampanoag craftswomen. In the course of trade, New England's tribes adapted European goods into their own culture for both practical and spiritual purposes.

On a coasting journey in the dead of winter, a band of Pilgrims hoping to trade for provisions from whatever Indians they found walked inland some distance and circled back again, to come upon "a place like a grave, but it was much bigger and longer than any we had yet seen. It was also covered with boards, so we mused what it should be, and resolved to dig it up."

Outlook on Tautog Cove from Fort Ninigret site. *Photo by author.*

The men, in their slow dismantling of the grave, found "bowls, trays, dishes, and such like trinkets"[1] between the mats placed above the body found inside. Roger Williams would write of the Narragansett ritual of Nickommo, a great feast and dance where "they give I say a great quantity of money, and all sort of their goods...to one person: and that person that receives this Gift, upon the receiving of it goes out, and hollowes thrice for the health and prosperity of the Party that gave it."[2]

Edward Winslow would write in astonishment of the ceremony he witnessed, where a great fire was lit, and those in the gathering, including visitors from neighboring tribes, would come forward and throw pots, bowls, dishes and silverware into the cauldron. During the early attacks on white settlements in what is now Maine and Vermont during King George's War, almost all of the English goods that filled the great houses the marauding natives burned were left for archaeologists to unearth three hundred and some years later.

What Europeans brought most to the Native Americans on New England's shores were diseases unfathomable to the native healers. Narragansett oral historians speak of a great plague among their people in the late sixteenth century. The first recorded incident of what seventeenth-century historians have called a plague occurred between 1616 and 1619. Elderly survivors described the symptom of yellowed skin and the remaining scars to the

Reverend Daniel Gookin. While the cause of the plague has long been debated, there is no doubt about the toll it took on the Native American population. As historian Karen Bragdon would write, "This terrible epidemic reduced populations among the Ninnimissinuok of the northern and central Massachusetts Bay by as much as 90 percent."[3]

Indeed, when the pilgrims came to realize the full measure of the tragedy that had befallen the Wampanoag, they were astonished that there were but sixty men under Massasoit's command.

William Bradford would write of the "sad spectacle" of bones left above ground and unburied. The pilgrims found in their coasting journeys abandoned fields and villages along the Massachusetts shore. Edward Winslow pondered the empty fields and thought of the "thousands of men…which died in a great plague not long since, and pity it was, and is, to see so many goodly fields, and so well seated, without men to dress and manure the same." Roger Conant would write some years later, as he reached Cape Ann, "Though all the countrey bee as it were a thicke wood for the generall, yet in divers places there is much ground cleared by the Indians…I am told that about three miles from us a man may stand on a little hilly place and see divers thousands of acres of ground as good as need to be, and not a Tree in the same."[4]

What Native Americans the Pilgrims did meet were remnants of once-thriving communities or transitional Native Americans like Squanto, who vacillated between the remnants of his own tribe on the Weir River and the larger Pokanoket (Wampanoag) tribe.

Conant would write of his native American neighbors in 1628, saying, "Upon the River of Mistick is seated sagamore John, and upon the River Saugus sagamore James…The elder brother, John, is a handsome young man…conversant with us, affecting English apparel and houses, and speaking well of our God. His brother James is of a far worse disposition, yet repaireth often to us. Both these brothers command not above thirty to forty men."

By 1630, the sachem Chickataubot, living near what became Quincy, Massachusetts, was said to have only fifty to sixty subjects, and the great empire of Nanepashmet, which extended from Chelsea to Marblehead, was now controlled by his sons, Wonouaham and Montowomsate, who between them "commanded not above thirty or forty men."[5] In 1633–34, smallpox ravaged the tribes along the Rhode Island and Connecticut coastlines, as well as the riverside communities inland.

Samuel Drake would write that illness began that year, among Native Americans in Plymouth: "During the autumn of this year the small pox

destroyed great numbers of the Indians…about Pascataqua River nearly all perish…About Plymouth too, many are carried off by a malignant distemper; with which about twenty of the pilgrims die also…In January of 1634 it was reported that the small pox had swept over the Narragansett country, destroying in its course seven hundred of that nation, and that it was extending among the westward of them."

Indeed, some native communities along the lower and middle Connecticut River were wiped out entirely. It was a plague that the sachem Canonicus never forgot. Years later, in rebuking the overtures of John Winthrop, he would complain to Roger Williams that the English had brought the disease to his people and that the Narragansett had mistrusted the English from the beginning.

This mistrust began to grow among neighboring tribes, a fact not lost on Tisquantum, better known as Squanto, who, to frighten Massasoit and his leaders, told them that the English at Plymouth harbored a great plague that they could unleash with a volley of their cannon upon the natives. The suspicion that white settlers were capable of poisoning the native populations did not deter trade, but neither was it ever discounted, and it was ultimately at the heart of events that led to the outbreak of King Philip's War.

BUT DISEASE WAS NOT all that came with the Europeans. The vices of greed and the consumption of alcohol, while certainly not unknown to the Native Americans, reached a new level once settlements sprang up along the coast. As early as 1626, Conant had recorded the incident of a Native American found frozen to death on Cape Ann, "reared up against a tree and his bottle…at his head." Often, to native leaders' alarm, the two vices were bound together, and the resultant mix of drunkenness and violence in cases presented before colonial courts is succinctly summarized by Samuel Drake and bears reprinting here:

> *Although from 1623–1675 there was no general War with the Indians in New England, yet there were often and frequent Disturbances…There were also frequent Quarrels and Murders among the Indians themselves, with which the white People had Nothing to do; though after such Occurrences, they sometimes espoused the Cause of the Party they considered injured, and used their Endeavors to bring the Offender to Punishment. So when any Wrong was done to an Indian by any of the Settlers, Justice was speedily extended to the injured Party. Of course Cases would often arise wherein, from conflicting Evidence, the Ends of Justice were frustrated.*

This was oftenest the Case when the English interfered with the Indians' private Quarrels, or Quarrels among themselves.[6]

Native Americans scarcely understood the English protocols of law. While they often presented their arguments in an elegant and persuasive manner, they resented the delays and further inquiries by the court.

Drake went on to say, "Hence the Party suffering by it often determined on taking the first Opportunity to be revenged; or as it used to be said, 'to right themselves.' In this way Feuds and Jelousies were perpetuated."

In numerous cases, both native and new Americans took the law into their own hands. There were attacks on white settlers in Massachusetts, as well as fighting brought to Ipswich by hostile Taratine warriors. These were the Abenaki, whose lands stretched into the territory now known as Maine.

Long hated among the Algonquian tribes, the Abenaki were not an agricultural or manufacturing people. Almost all they owned came from plunder, as they raided storehouses along the coast of Massachusetts and randomly attacked villages in the course of their travels.

In the fall of 1631, trader Walter Bagnal was murdered at his trading post on the Saco River. As Bagnal was known to overcharge the natives for goods and had engaged in many an argument in trade, it was believed that had been his undoing.

According to Drake's *Old Indian Chronicles*, in the winter of 1631–32, Taratine warriors came upon Henry Way's boat in the waters off Dorchester. Way, three friends and his son were all murdered, and the boat sunk with stones to "hide the Evidence of their Barbarity."

In the aftermath of the hunt for these Indians and subsequent hanging of at least some of the perpetrators, soldiers were sent to Ipswich and, from shore the next spring, watched as "twenty canoes full of them" paddled past Ipswich, though "they did not dare to land."[7]

Fighting also broke out between the Narragansett and the Pequot. Canonicus, the Narragansett sachem, enlisted the help of Massachusetts tribes in Neponset and Winnisemmet. Though the skirmishes were largely confined to the swamps and woodlands of Rhode Island and Connecticut, some of the Massachusetts warriors attacked homes in Dorchester in August and were soon "set in the Bilboes at Boston." This method of shackling the perpetrator to a heavy iron bar by the wrists or feet was likely the first English-style punishment encountered by Native Americans. In September, another trader from Dorchester was killed, and the sachem Passaconay reportedly "pursued and captured the Murderer," as well as meted out a

Mashamoquet Brook Park, outside of Putnam, Connecticut. *Photo by author.*

punishment that satisfied the authorities. At the same time, courts in Boston came down hard on those convicted of selling gunpowder and shot to the Native Americans. The court even considered the death penalty for this offense and was equally harsh with those settlers who committed acts that might provoke neighboring tribes. For example, one Nicholas Frost was branded and banished from the colony after "stealing from the Indians at Damerill's Cove."

In January 1633, a group of Englishmen seized the former Nahant sachem Poquanam at his home on Richmond's Island. Known as "Black Will" among the white settlers, he had long been suspected in the murder of the trader Bagnel. The whites lynched him and left in pursuit of pirates. There is no record to indicate that these men ever met justice for their crime.

Such was not the case in 1638 for one Arthur Peach and two unfortunate men he enticed into his murderous scheme. Peach was described as "a young desperado, who had been a Soldier in the Pequot War, and done notable Service."[8] It seems that after his time as a soldier, he sought a life of adventure and headed to the Dutch settlement on the Hudson River, where he met Thomas Jackson and Richard Slinnings. He soon enticed the men in the settlement to leave their masters and join with him in traveling the eastern

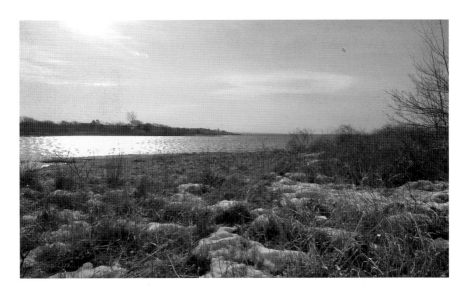

Brushneck Cove, Warwick, Rhode Island. *Photo by author.*

seaboard. Three men joined Peach, Jackson and Slinnings and traveled south through the woods. At some point, they met up with Penowanyanquis, a Narragansett courier who was traveling with a significant amount of wampum. After proposing the deed to his fellow travelers, Peach invited Penowanyanquis to sit and smoke with them, an invitation that was accepted.

When the opportunity came, Peach ran through the Narragansett courier with his sword, and the men robbed him of his wampum, leaving the Indian for dead. Though mortally wounded, Penowanyanquis managed to make it back to his homeland and give details to the Narragansett about the men who had robbed him before he died. Narragansett sachems immediately sent men in pursuit of Peach and the others. They captured Peach, as well as Jackson and Slinnings, who were marched to Rhode Island, where the three were thrown into prison.

With the Narragansett sachems demanding justice over the incident, the authorities of Plymouth County, where the murder had taken place, took hold of the matter, and the three men were executed in Plymouth on September 4, 1638.

Ironically, during the same years that this tension and resultant events were taking place, those logging journals and writing books to be consumed back home in Great Britain were portraying Native Americans in a positive light.

In the chapter of *Mourt's Relation* entitled "A Journey to Pokanoket: The Habitation of the Great King Massasoit," Edward Winslow recounts the

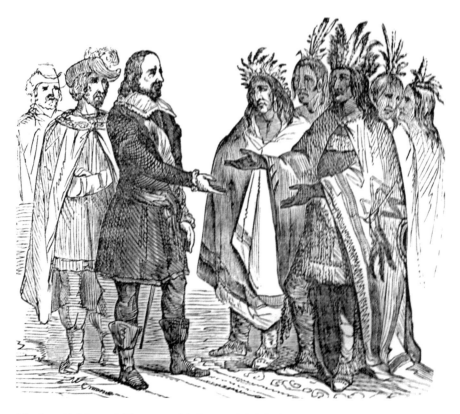

Meeting with Massasoit (Oussamequin). *Courtesy of the John Carter Brown Library at Brown University.*

days in June 1621 when a band of the Pilgrims spent several days in the company of the sachem:

> *He lighted tobacco for us and fell to discoursing of England, and of the King's Majesty, marveling that he would live without a wife. Also he talked of the Frenchmen, bidding us not to suffer them to come to Narraganset, for it was King James his country, and he also was King James his man. Late it grew...So we desired to go to rest. He laid us on the bed with himself and his wife, they at one end and we at the other.*

In his *New England's Prospect* (1634), William Wood wrote of the tribes that populated southern New England:

View of the Charles River from present-day Waltham. The remains of a Norse "lookout" lie on the southern bank nearby. *Photo by author.*

The Pequots be a stately, warlike people, of whom I never heard of any misdemeanor, but that they were just and equal in their dealings, not treacherous either to their countrymen or English, requiters of courtesies, affable towards the English. Their next neighbors, The Narragansets, be at this present the most numerous people in those parts, the most rich also, and the most industrious, being the storehouse of all such kind of wild merchandise as is among them.

The Narragansett fished, hunted and trapped beavers, muskrats and otters for the English and traded them for commodities, which they sold to inland tribes at a profit. They also manufactured "great stone pipes, which will hold a quarter ounce of tobacco," as well as bowls and utensils for trade. The tribe is estimated to have numbered about four thousand during this period, but as Wood wrote, "Although these be populous, yet I never heard they were desirous to take in hand any martial enterprise or expose themselves to the uncertain events of war…they rest secure under the conceit of their popularity and seek rather to grow rich by industry than famous by deeds of chivalry."

Puritan minister and trader Roger Williams came to know the Narragansett better than any European visitor. He would remark, in his *A Key into the Language of America* (1643), "I have acknowledged amongst them an heart sensible of kindnesses, and have reaped kindnesses against from many, seven yeares after, when I myselfe had forgotten."[9]

Yet while these visitors were writing warmly of their interactions with Native Americans, many settlers arrived with a predestined sense of conquest and a vision of New England as a God-given gift of resources, nearly rid of savages that would impede the steady growth of profits such resources would provide.

In Edward Johnson's *Wonder-Working Providence of Sions Savior in New England* (1654), the first general history published of the region, the Puritan justification of establishing a "new eden" in the wake of these devastating plagues is articulated for the first time. Writing of the smallpox epidemic of 1619, Johnson says, "As the ancient Indians report, there befell a great mortality among them, the greatest that ever the memory of Father to Sonne took notice of, chiefly desolating those places where the English afterward planted…by this means Christ…not only made room for his people to plant; but also tamed the hard and cruell hearts of these barbarous Indians."[10]

Johnson may have known that the diminished numbers of Native Americans may have led their leaders to sign an alliance with Plymouth that led to a relative—if at times uneasy—peace for close to fifty years. The Massachusetts Bay Colony summoned native leaders repeatedly to Boston, sometimes successfully and sometimes not. The Narragansett in Rhode Island kept the colonists at arms length, using Roger Williams as an intermediary with John Winthrop and, later, his son and namesake in Connecticut, but they were always mistrustful of English intentions. Colonial authorities were also mistrustful of the Indians, especially as carefully laid out English-style court systems had failed to corral tensions between settlers and Native Americans.

Authorities were assuaged for a time by efforts to moralize the Native Americans, first by the writings of European religious thinkers that envisioned the Native Americans as part of the "lost tribes of Israel" and then by those who sought to evangelize among the Indians. These efforts largely began with minister John Eliot in 1640 when he began to learn the Massachusetts language in order to preach to the natives in their own tongue and began to conceive his greatest work, the translation of the King James Bible into the Algonquian language.

He preached his first sermon to Roxbury natives at a gathering just outside of town in 1646 and also began to establish separate communities

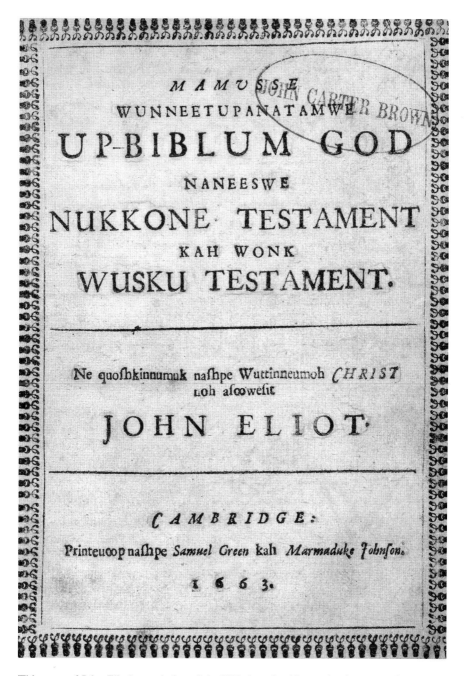

Title page of John Eliot's translation of the Bible into the Algonquian language. *Courtesy of the John Carter Brown Library at Brown University.*

for those Indians who had converted. Historian Linford Fisher has written, "Between 1646 and 1675 Eliot founded fourteen 'praying towns' throughout Massachusetts, in which he gathered Christianized Indians into highly organized towns designed to inculcate European cultural, religious beliefs, and agricultural methods." Eliot sent pamphlets on a regular basis to wealthy backers in England, a group that would come to call itself the Company for the Propigation of the Gospel in New England and would eventually fund other ministers throughout the region.

The Reverend Thomas Mayhew Jr. established a similar community on Martha's Vineyard, and the Reverends James Thompson and James Fitch were sent to preach to the Pequot and Mohegan in 1657. Eliot's Gospel was published in 1660 and seemed to establish a hope for increased evangelization, but these efforts and the communities established were always controversial among the native populations. While some Massachusetts Indians saw these "towns" as a way of stabilizing the large losses of land they had suffered, the Massachusetts court, in negotiating the land grants with Eliot, required local natives who moved into the towns to sign away all current and future rights to vast tracts of land.[11]

After the death of Massasoit in 1661, the peace that he had brokered with Massachusetts authorities began to unravel. The mysterious death of his eldest son and heir apparent Wamsutta (Alexander) while in English hands exacerbated Wampanoag mistrust of the English, and with the succession of his younger brother Metacom (Philip) as sachem of the tribe, this mistrust became more vocal. According to John Easton, Philip and his counselors told Rhode Island authorities that his tribe "had a great fear to have ani of their indians...called or forsed to be Christian indians. Thay saied that such wer in everi thing more mischivous, only disemblers, and then the English made them not subject to their kings, and by ther lying to rong their kings."[12]

Tensions were also exacerbated as speculators and second-generation settlers continued to take land or settle away from townships, where authority and spiritual guidance were far removed from their doorstep. As historian Jill Lepore would note:

> By the 1670s in the years before King Philip's War broke out, there were many signs that the English had degenerated. Church membership and church attendance had declined. People were settling farther and farther from the coast, nearer to the Indians, and farther from the civilizing influence of English neighbors. Trade and contact with the Indians were increasing, though little of this contact involved sharing the good news of the gospel.[13]

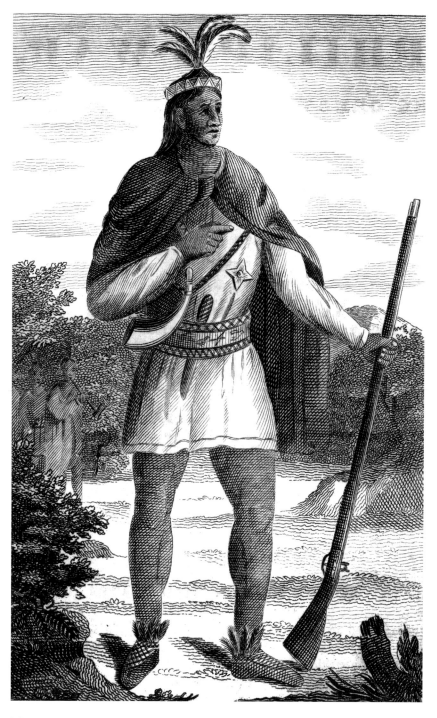

Metacom, or King Philip. *Courtesy of the John Carter Brown Library at Brown University.*

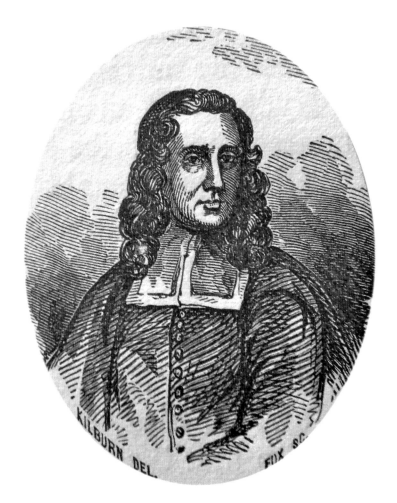

Portrait of Increase Mather from Samuel Drake's *History & Antiquities of Boston.*

Puritan minister Increase Mather cautioned New Englanders in a series of jeremiads, or sermons—most notably, in "The Day of Trouble is Near"—about the "great decay as to the power of godliness amongst us." Other ministers in similar jeremiads spoke to the rise in violence, drunkenness and lewd behavior that "turnith man into a bruit beast."

The suspected murder of Christian Indian John Sassamon has long been pointed to by historians as the turning point that led to war, but as we have seen, the disputes over the taking of land, the attempted and mostly failed Europeanization of Native Americans and the subsequent threats to their own beliefs and culture would breed these ill suspicions of both English and

Indians against one another, and would inextricably draw them into armed conflict. When war finally erupted in the spring of 1675, historian Linford Fisher writes that the fighting

> *pitted Indian against Indian and Christian against Christian…while Wampanoags, Massachusetts, Narragansetts, Nipmucks, Pocomtucks, and Abenakis all fought against the Euroamericans, the Mohegans, Pequots, Mohawks, Christian Wampanoags, and a smattering of other Christian Indians from a variety of native groups fought alongside the New England colonists and aided them in countless ways as spies, interpreters, messengers, and assassins.* [14]

The war exposed the skepticism and hostility that the second generation of settlers held for Native Americans living among them. Where those indigenous people had once been seen in English eyes as being contrary and inferior, the early colonists had mostly held them as kindred spirits, if not yet civilized.

But the conflict turned the narrative into one of biblical and metaphorical rhetoric, portraying the Native Americans as heathen savages—or, in the biblical term of the time, Ameleks—who would surely rise against those saintly new Americans striving to bring forth a new Israel in the wilderness. In this vein, the New England Confederation declared war in 1675 on the Narragansett, whose sheltering of Wampanoag elders and women was seen as complicity and evidence of the greater conspiracy to drive the whites from the land, saying, "So Satthan may combine, and stir up many of his instruments" in the same way that the "Amalek and the Philistines did confederate against Israel."

The diary of Samuel Sewall, who would later become a judge during the Salem witch trials, casts light on the violence of the times:

> *Friday about 3 in the afternoon, April 21, 1676, Capt. Wadsworth and Capt. Brocklebank fall. Almost an hundred since, I hear, about fifty men, slain three miles off Sudbury: the said Town burned, Garrison houses except.*
>
> *Friday May 5, 16 Indians killed: no English hurt: near Mendham, 19 May. Capt. Turner, 200 Indians. 22 May, about 12 Indians killed by Troop.*
>
> *June 22. Two Indians, Capt. Tom and another, executed after lecture….Note. This week Troopers, a party killed two men, and took an Indian Boy alive.*

Illustration of the attack on Deerfield from John Lewis Thompson's *History of the Indian Wars and War of the Revolution of the United States* (1887).

> *Just between the Thanksgiving, June 29, and Sab. day, July, 2, Capt. Bradfords expedition 20 killed and taken, almost 100 came in: Squaw Sachem.*
>
> *Saturday, July 1, 1676. Mr Hezekiah Willet slain by Naragansets, a little more than Gun-shot off from his house, his head taken off, body stript. Jethro, his Niger was then taken: retaken by Capt. Bradford the Thorsday following.*

Willet's slave had seen the English in the woods and run up to them. He told Bradford's party that Philip had about a thousand Native Americans of "all sorts" with him but that many were sickly. Three had died while he was in captivity.

Later that summer, even as Indians came into Plymouth to "prove themselves faithful," Sewall heard of "one hundred twenty one Indians killed

Illustration of a garrison house under attack from Thompson's *History of the Indian Wars.*

and taken" and then of the English victory in Medfield where Canonicus II was captured. He also heard the ominous report of "One Englishman lost in the woods taken and tortured to death."[15]

Whites were equally brutal during the war. From an account given to Thomas Hazard by Daniel E. Updike, after the massacre of Narragansett elders, women and children at the Great Swamp, the regiments from Connecticut and Massachusetts made the tortured trip back through the snow and ice to Smith's Trading Post, where they had encamped. The morning after their return, the Connecticut officers marched out "a fine-looking young Indian warrior, whom they had captured after the battle, into the orchard, and out of pure cussedness and for sport, placed his head on a tree stump and chopped it off with a wood axe."[16]

In Taunton, Massachusetts, in August 1676, a group of twenty men led by a turncoat Indian surprised a band led by Queen Weetamoe. In the ensuing skirmish, Weetamoe attempted to escape by crossing the Taunton River "upon a raft, or some pieces of broken Wood." She was later found, naked and drowned on the Swansea side of the river. Those that found the queen mutilated her corpse, paraded it through the town of Taunton and placed her for public display on the village green.[17]

When Philip was killed at Mount Hope on August 12, 1676, the Native American who fired the fatal musket shot was a disenchanted Pocasset who

Death of Philip from Thompson's *History of the Indian Wars.*

had joined the English in scouring the woods of Southeastern Massachusetts for the Wampanoag leader and his subordinates. The sachem's body was beheaded and quartered at Benjamin Church's orders and the limbs hung from a tree. Alderman, the native who had killed Philip, was given one of the sachem's hands, it "being much scarred, occasioned by the splitting of a pistol in it formally," and Philip's head was carried away by the triumphant English soldiers.[18]

The very brutality of King Philip's War was to cast a long shadow over New England, and like the grisly remains of the sachem's head, placed in a cage and hung before the Plymouth Courthouse, the memories of the savagery on both sides were slow to decay and transposed the war into a darker metaphor. The Puritans, especially, seemed vexed by the Native Americans' rejection of the gospel, even among those Christian Indians, many of whom had been secreted away from their communities, for there were some who fought with their people against the whites and their native allies. Eliot's Bibles,

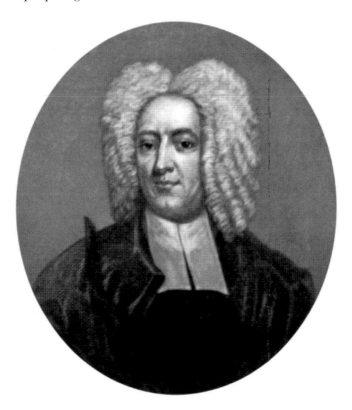

Portrait of Cotton Mather from Samuel Drake's *History & Antiquities of Boston* (1856).

printed in the Massachusetts language, were gathered up by marauding Indians and destroyed.

Cotton Mather, though but a toddler when the war erupted, would, by his own account, ride his horse as an adult to Plymouth and pluck the jawbone from Philip's skull as a souvenir. Though his father had taken a milder approach to the Native Americans in his history of the war, Cotton had no doubt that what had begun in the spring of 1675 was a holy war that would likely last his lifetime. In his biography of minister John Eliot, he summarized what the Puritans faced on their arrival:

> *The natives of the country now possessed by the (New Englanders) had been forlorn and wretched (heathens) ever since their first herding here; and tho we know not when or how these Indians first became inhabitants of this mighty continent, yet we may guess that probably, the divil decoy'd those miserable savages hither, in Hopes that the Gospel of the Lord Jesus would never come here to destroy or disturb his absolute empire over them.*[19]

In the throes of the conflicts that occurred for nearly three decades after King Philip's War, Mather would exhort those joining the fight against "these Amaleks now annoying this new Israel in the wilderness" to "turn not back till they are consumed…tho they cry, let there be none to save them; but beat them small as the dust before the wind."

But underlying this hatred of the Native Americans and these efforts at their elimination was the fear that the hoped-for "new Israel" was not going to be. The isolation and relative numbers of men compared to women had begat violence from the beginning in the form of fistfights and skirmishes among neighbors. But in rural areas, in particular, isolated cases of odd and alarming behavior began to emerge with greater regularity. Worse still, those who came to the colonies in the generations after the Puritans established their religious communities were a decidedly secular wave of immigrants. John Winthrop had complained as early as 1641 in his diary that "as people increased, so sin abounded."

In the aftermath of the Indian wars nearly forty years later, Increase Mather would bemoan those settlers who were "all ready to run wild into the woods again, and be as heathenish as ever."

It was a grim time for the remaining Native Americans as well. John Eliot, who resumed his missionary work after King Philip's War, would write despairingly of the fate of his "praying towns." Reduced to but four, the inhabitants had already adapted the habits of the local soldiers with

whom some had served against the Wampanoag and their allies. Eliot recorded that the soldiers welcomed the Indians whenever their paths crossed and "had them to the Ordinaries, made them drink and bred them by such an habit…They learned so to love strong drink that they would spend all their wages & pawn anything they had for *rumb* or strong drink. So drunkenness increased and quarreling, and fighting and more."[20]

But it would be Cotton Mather who would attempt to turn the mirror on those he saw as being little more than those savages that the survivors of the war had feared for so long. In an irony that surely could not have been lost upon the Boston minister, the younger Mather now blamed the remaining Native Americans and their vices of drinking, gaming and carefree wandering as an evil influence on these later generations of settlers. "We have become shamefully inhumanized in all those abominable things…our Indian wars are not over yet."

Indeed, Mather's war to exterminate the last shred of nobility of Indian belief and culture was to last far longer than Metacom's desperate effort to rid the land of the whites.

Illustration of captive white woman and Native American from Thompson's *History of the Indian Wars.*

Though in the first histories of New England, the Native American leaders would come to be eulogized as heroic defenders of their land, their descendants became vilified for their ongoing struggle with the European-borne disease of alcoholism, their abject poverty after the war and their continued resistance to adapt to the English style of living.

As these and later popular histories were written, they often included colorful stories from local communities. These "Indian tales" all held some moral invective and reflect the vices and shifty behavior that became associated with Native Americans. They underscore the prejudice that white Americans displayed toward the natives during this period. These tales of wandering Indians, itinerant and lazy, sure to be drunk at any given time of day, reduced a once proud race to individuals who were hapless, overindulgent and essentially lost in the afterlife.

One of the earliest stories from Rhode Island involves the ghost of an itinerant Indian who haunted a room of the Black Horse tavern in North Scituate, Rhode Island.

The tavern had been in the family for several generations by the time that Ruben Jenks became the keeper and the hauntings began. Guests in one particular room complained of being woken at night by the terrible vision of a fully dressed warrior yielding a tomahawk above their heads. This occurred so frequently over a period of time that the place soon had a reputation far and wide for its "Indian Room." Friends told Jenks that the ghost was that of an indigent Indian who had frequently loitered at the Pine Tree Tavern up the road and was doubtless determined to scare customers away from the rival establishment. When Mrs. Jenks took the room for her own, the visitations took a different turn.

According to the story, the Indian's ghost gestured to Mrs. Jenks and led her outside to a large cedar by the front gate. He pointed to the base repeatedly and muttered in broken English about needing to revenge an insult to his race. When Mrs. Jenks relayed the visitation to her husband, he determined that the place where the Indian had pointed must contain some treasure he had kept secret and dug furiously in vain around the base of the tree. Later visitations brought Mrs. Jenks outside to other trees on the property, all of which her husband dutifully dug around, including in the orchard, which was nearly destroyed in the search for treasure. Eventually, Jenks decided, as did his friends, that the ghost was merely bent on destroying his livelihood. One night, the Indian spirit came to Jenks's daughter and led her to the old barn behind the tavern. Leading her inside, he gestured and spoke in broken English to the girl, making her understand that an old blackened

Black Horse Tavern, Scituate, Rhode Island. *Photo by author.*

trunk in the loft of the barn held the key to his disgruntled spirit. Though her mother was skeptical, she unearthed the trunk and opened it. Inside was a mannequin head and materials for making wigs. It seems that Jenks grandfather had doubled as a wig maker in his time owning the tavern, and this Indian, on attempting one night to scalp a visitor to the inn, had walked away in anger and shame with a bloodless wig in his hand. Thus he laid his revenge on the present visitors.

The tale was purportedly first written down by one Parson Pillsbury, who had been witness to Rueben Jenks's attempts to find the treasure and recorded the "Indian speak" as reported by Jenks's daughter. It was republished several times in popular titles at the turn of the nineteenth century, including Edward Field's *Colonial Taverns* and most expansively in Alice Morse Earle's *Stagecoach and Tavern Days.*

In her summary of the tale, Mrs. Earle concluded that the itinerant Indian "simply belonged to a class of ghosts…that…have a passion for pointing out places and saying treasure or skeletons are buried therein; wheras it always proves that nothing of the sort is ever found."

While a whimsical ending for white readers, the caricature of a poverty-stricken Indian lurking about a tavern in the afterlife is a purely white reflection of those "wandering Indians" as they were portrayed in the

aftermath of King Philip's War. Parson Pillsbury may have persuaded himself that attaching a moral lesson, as from those biblical texts used as inspiration for his sermons, was an appropriate use of poetic license, and he was not alone in this respect.

Anthropologist William S. Simmons writes that these treasure-hunting dreams are quite common in both European and American mythology. There were many tales about the greed and the ills brought on by the pursuit of riches. They are not, however, indigenous to New England's Native Americans. In *Spirit of the New England Tribes*, his seminal book on the folklore of the indigenous peoples of the region, he writes, "Early historic New England Indians often buried their most valuable possessions with the dead and did not excavate graves to obtain their contents...New England Indians would rather see archeological sites and burial grounds left undisturbed. Thus, not only was the treasure story alien to the aboriginal tradition, but Indians disapproved of attempts to recover whatever treasures their ancestors might have buried."

By the late nineteenth century, such tales had been incorporated into Native American mythology, but it is nearly always the Europeans lured

Queen's Island from the shore of Cocumscussoc, near Wickford, Rhode Island. *Photo by author.*

to the treasure, often by the devil himself, as in the Mashpee tale of the Frenchman who sold his soul for a pot of gold.[21]

In this new colonial mythology, spirits that deceived gullible people like Jenks were not tethered to this earth of their own free will but were often associated with the devil or his "imps." In this respect, Native American places of history often became the haven of these spirits.

In Charlestown, Rhode Island, the site known as Coronation Rock, the place where the sachems of the Narragansett people were received, became a lonely and desolate place with the tribe's reduced numbers. In this period, the site became woven into New England folklore with the tale of one Tom Rodgers, most popularly recorded by Edward R. Snow.

Rodgers, it is said, was originally from Nantucket, and perhaps that upheaval from his island home, with the "wilderness" suddenly outside his door, gave him the certainty that the region in which he now lived was haunted, and he had heard such stories about spirits gathering at Coronation Rock. One night, after drinking a good quantity of spirits to fortify his courage, he set off for home and wandered close to the woods where the rock lay. Snow writes:

> As he approached the rock he saw a glow through the trees and heard the sound of a fiddle playing like mad, and when he reached the rock he saw that a wild dance was in progress. Finding a mischievous looking maid alone on a mossy hummock, Tom quickly took her by the waist and took her to the clearing—as they danced, he had the sensation of soaring above the clearing and noticed that the crowd were now seated watching them dance. As they separated and came back again, Tom noticed his partner's features were changing from the rosy-cheeked girl he first noticed to that of a lank and withered hag whose eyes now glowed green with evil, and whose sharp teeth now projected from the once delicate mouth. He flung off his coat, hat, and vest, and then fled for his life, tumbling once in the woods and hearing growling, hissing, and a strange language about him. He had the sensation of a hideous form hovering over him.[22]

When Rodgers woke in the woods the following morning, he noticed that his jackknife bore two portraits of the witch he'd met the night before. When he reached home, he fell ill for a time but recovered. In the coming months, he would eschew alcohol, get married and became a member of the church, eventually becoming "a deacon in good standing."

The moral lesson is clear in this story, no doubt originating with the backlash against the looseness of morals and the frivolity that had become

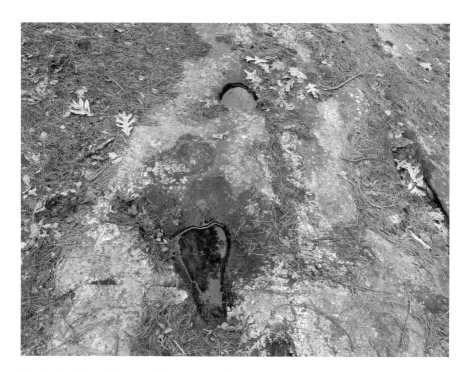

Devil's Foot Rock, Kingston, Rhode Island. *Photo by author.*

prevalent in the taverns by this time. Such religion-based morality tales also mingled with Native American mythology.

One such tale, which has prevailed into the twenty-first century, is the story associated with the area popularly called Devil's Foot Rock in North Kingston, which, before European arrival, had long been a gathering place for the Narragansett.

By 1671, the rock had become a boundary marker for the settlers of Fones Purchase and thus was out of Narragansett hands. Situated just north of Wickford, in the town of Kingston, Rhode Island, the Devil's Foot Rock is part of a long, granite ledge that had once been hidden deep in the woods. It was exposed as a railway, and then a road was built near the site in the twentieth century. The tale has a few variations, but it has remained largely intact in modern folklore. The legend of Devil's Foot Rock is an intermingling of Native American and white beliefs. The story's first appearance in print seems to be in 1850, though by then the tale had been told for generations.

An Indian woman had murdered a white man (either in Boston or Wickford, depending on the version). She made her way to the ledge and

there knelt and prayed to Hobomoken, the Algonquian god who was both a benevolent and cruel deity, often called upon when a Native American faced an insurmountable uncertainty over an event or the fate of a loved one.[23]

As she prayed, a stern-faced Englishman appeared beside her. Believing herself to be discovered by the white authorities, she attempted to escape but was seized by the arm. She again called out to Hobomoken to save her, but the black-frocked Englishman told her, "I am Hobomoken." Grabbing her by the waist, he stomped his feet on the rock and took her in flight to Purgatory Chasm, from which he flung her into the turbulent waters below.

In his version of the story, historian Edward R. Field concludes the tale by telling readers that "to this day may be seen near Wickford, the footprints of Satan on the surface of the ledge near the road. One has the form of a cloven hoof, and the other has the shape and size of a human foot, even to the mark of the great toe."

In other versions of the story, the last mark of the devil can be found on a ledge on Block Island, said to be where Satan landed before diving into Block Island Sound.

Other tales from the East Coast concern similar impressions that have been interpreted in folklore as the Devil's footprints. In Monteville, Connecticut, a similar impression on the rocky ledges of Shelter Island is said to be the stepping off point for the legend that states: "When the Evil Spirit left the island he took three long strides, the first on Shelter Island, the second on Orient Point, and the third on Montauk, whence he plunged into the sea."

The Rhode Island tale, however, is more firmly rooted in moral tradition. In the popular version that appears predominantly in white folklore, the Indian woman, fleeing from a crime, is brought to justice by the devil, the very deity she prayed to for mercy. Conversely, the Native American interpretation of the stern Englishman in the "devil's disguise" has precedent in seventeenth-century evocations of Hobomoken, also called "Cheepie" in other Algonquian tales. In his *Two Voyages to New England* (1673), the minister Daniel Gookin recounts the experience of being woken by three natives and told that they had fled from a vision of Hobomoken. He writes, "Two Indians and an Indess came running into our house, crying they should all die. Cheepie was gone over the field gliding in the air with a long rope hanging from one of his legs: we asked what he was like, and they said all wone Englishman, clothed with a hat and coat, shoos and stockings."

Reverend Hope Atherton is the subject of a later incident during King Philip's War. He signed on as chaplain for a cavalcade of garrison troops and volunteers from neighboring towns, which mustered to rescue three men

who had been captured during an attack on Hatfield, where Atherton was the local minister.

The troops made their way into Deerfield and then Greenfield and continued to track the warriors until they found their camp down the slope of a hill across the Falls River. They attacked just before daybreak and routed the camp. However, their assault alerted other Indian encampments nearby, and the cavalcade was soon in retreat. In the mêlée, Atherton had been unhorsed and walked toward a band of native warriors unscathed to give himself up, but they fled at the sight of him in his black cloak, believing that "he was the Englishman's God."[24]

Many of these "Indian tales" survive in print and on the Internet today as anecdotal expressions of an earlier time that predates our own fascination with rural and urban legends and the paranormal investigations that have become popular on television. We should not lose sight, however, of how these tales came to be told and written and continued to form an unflattering perception of our indigenous peoples for generations of readers.

Chapter 2

ERRANT IN THE WILDERNESS

*R*eaders of this history will likely be familiar with the famous nineteenth-century painting by George Henry Boughton that depicts a group of Pilgrims in a procession to the meetinghouse. The procession is led by two men with muskets, behind which are a cloaked minister and his wife, followed by three women and two children. They are flanked by stern-looking men with muskets who peer intently into the woods surrounding them. Inspired by a popular American history of the period, the inference from the painting is usually that this band of Pilgrims was wary of the local Native American population. Yet the likelier concern among these and other early settlers were the packs of wolves that roamed early New England.

William Wood wrote, "The wolves be in some respect different from them in other countries. It was never known yet that a wolf ever set upon a man or woman. Neither do they trouble horses or cows." But he made no bones about the menace of wolves to the early farms in New England, writing, "Swine, goats, and red calves, which they take for deer, be often destroyed by them…In the time of autumn and in the beginning of spring, these ravenous rangers do most frequent our English habitations, following the deer which come down to those parts."

Wood described the wolves as: "much like a mongrel, being big boned, lank paunched, deep breasted, having a thick neck and head, prick ears, and long snout, with dangerous teeth, long-staring hair, and a great bush

Illustration of Plymouth Colony circa 1622, from Powell's *Historic Towns of New England* (1896).

tail…Many good dogs have been spoiled by them. Once a fair greyhound, hearing them at their howlings, run out to chide them, who was torn in piece before he could be rescued."

To the Pilgrims and Puritan settlers, wolves seemed to move like ghosts through the new wilderness, silent and menacing. Their howls at night were unearthly to those who had perhaps learned of European legends, and as John T. Coleman suggests, the biblical metaphors of the wolf suddenly came to light with the constant need to protect livestock. Wolves were seen as "skulking criminals" that knew no end of greed and theft.

Edward Winslow recorded that encounters with wolves occurred early in Plymouth when men ventured into the woods. In mid-January 1621, as the settlers were beginning to build lodgings outside the main house they had constructed, two men went into the woods to gather thatch for roofing.

They were accompanied by a mastiff and a spaniel. Before long, the dogs had flushed a deer out of the thickets and gave chase. The men followed and soon became lost. They spent a restless night in the woods, believing the howls of wolves to be lions, and they feared for their lives. They made it back to the settlement the next day and told the others of their ordeal. Two days later, John Goodman beat off two wolves that attacked his dog while hunting. The following month, a settler identified as "Master James" had shot five wild geese and was making his way back to the plantation when he came upon a pack of wolves devouring a deer alive that had been trapped in a snare by local Indians.[25]

Bounties to protect livestock were usually among the first edicts in the early colonies. In Plymouth, where William Bradford would record in October 1624 that still "the countrie is annoyed with foxes and wolves," a bounty of two pence was established per wolf "for the incouragement of persons to seek the destruction of those ravenous creatures." The problem persisted, however—so much so that the bounty was abolished

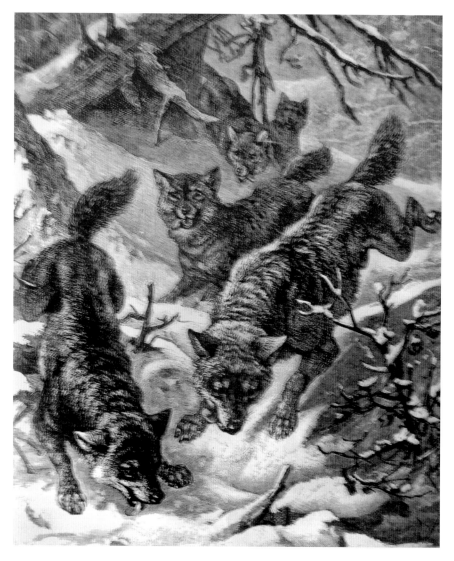

Illustration of a wolf pack tracking their prey, from the Reverend J.G. Woods's *Our Living World* (1885).

by 1633 and changed to five bushels of corn, a more valuable commodity in the colony, for one or more wolves that were destroyed. The fledgling community of Boston was also beset by the predators, for John Winthrop would write that in 1631, the wolves "did much harm to calves and swine between Charles River and Mistic." Two years later, he would note: "The wolves continued to do much hurt among our cattle."

The Reverend Samuel Smith, writing to his son Ichabod in 1699, recalled that as a child when the town of Wethersfield, Massachusetts, had been founded:

> *The first meeting house was solidly made to withstand the wicked on-slaught of the Indians…for many and great was the terror of them…After the redskins the greatest terror of our lives at Wethersfield, and for many years after we had moved to Hadley to live, was the wolves. Catamounts were bad enough, and so was the bears, but it was the wolves that was the worst. The noise of their howlings was enough to curdle the blood of the stoutest, and I have never seen the man that did not shiver at the sound of a pack of them.*[26]

By 1641, it became law for each town to bait and set traps for wolves and to "look daily after wolf traps, under penalty." In 1651, the colony sought assistance from Native Americans, providing a coat in trade for every wolf pelt brought into Plymouth. Boston enacted a bounty for wolves in November 1639, as Providence had early on. Roger Williams called them "fierce, bloodsucking persecuters" and enjoined every townsman to rid the area of wolves.

There is mention of granting one Tho. Roberts "a share of meadow laid out to him in ye swamp" where he could lay his "woolfe trap," but the town did not officially create a bounty until the January meeting in 1659, when it was ordered that "whosoever shall from this tyme forward kill any woolves, that they shall have for each woolfe, a halfe penny a head for each head of catell, they who kill the Wolfe to gather it vpp; provided they kill them within Providence Limetes."[27]

One recipient of this bounty was Benjamin Hernton (Herndon), a nefarious citizen of the town who often quarreled with neighbors and the court alike but was apparently a valued hunter. We find that in the October meeting of 1667, it was ordered that he should "receve according to ye Towne order Concerning wolves a halfe penny per head for all and Every of the Chattle in this Towne."[28]

The bounties were of considerable profit to some. The early town records show that in January 1680, Thomas Fenner "come to ye office desirein that cognizance might be taken, they had (then) lately killed two wolves (within our townshippe)."

David Whipple and Edward Inman also sought bounties in February 1681. The following month, John Haughkines (Hawkins) sought the bounty

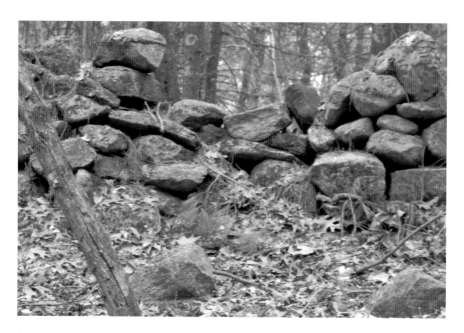

Stonewalls in Mashamoquet Brook Park in Putnam, Connecticut. *Photo by author.*

for a wolf he had killed. In December 1683, John Mathuson also brought the head of a wolf to the council meeting.

The domestic livestock duly imported to New England proved unwieldy to maintain in the landscape of New England. Fences were in constant need of repair, and most of the colonies made it law that townsmen maintain their fences, but stray cattle and swine were always getting into the woods.

In the early days of the common, a community meadow for citizens' livestock, wolves were a constant threat. Roger Williams helped large cattle and sheep owners acquire the islands of Narragansett Bay from the sachem Canonicus and his nephew Miantinomo, but the poor farms of Providence were still under siege. Despite the efforts of digging traps, the bounties offered and even, as historian Joseph Adler noted, experimenting "with exotic technologies like mackerel hooks and wolf bullets with adder's tongues," the wolves continued to menace the settlers' livestock.

In the aftermath of the bloody Pequot war, Roger Williams suggested that those captive Native Americans be "Divided and dispersed" with "a tribute of wolves heads be imposed on them etc. wch (with Submission) I conceave an incomparable way to Save much Cattell alive in the land." Towns encouraged farmers to "purchase hounds and mastiffs and train them to hunt wolves."

A generation later, those dogs that had become strays or were adopted into Indian packs were becoming a problem as well. An order of 1661 from the town of Providence assigned Valentine Whitman and Thomas Clemence to "go unto the Indians dwelling at Pomecansett, and unto those Indians living neere this Towne, and warne them to Take some course with theire Dogges, to Keep them from ffalling upon the Inglish cattell or else the must Expect to have theire Dogges Killed."[29]

William Wood concluded that "they be the greatest inconvenience the country hath" and reported, "These be killed daily in some place or other, either by the English or Indian, who have a certain rate for every head. Yet there is little hope of their utter destruction, the country being so spacious and they so numerous, traveling in the swamps by kennels. Sometimes ten or twelve are of a company."[30]

Such was the lore of the wolf in New England that they would be used metaphorically to incite the colonialist's worst fears during King Philip's War. Increase Mather, in what would become a well-known jeremiad, would prey upon the fear of these "perilous times…when men can scarcely look out of doors, but they are in danger of being seized upon by ravening Wolves, who

Path to Wolf Den, Mashamoquet Brook Park. *Photo by author.*

lye in wait to shed blood, when men go not forth into the field, not walk by the way side, but the Sword of the Enemy, and fear is on every side."[31]

A single incident in the winter of 1742 would establish a young man's reputation in his community and open the door for him to become one of the officers of the American militia gathered at Bunker Hill. During that winter, a gray she-wolf, long reputed to be the last in Pomfret, Connecticut, continually attacked sheepfolds in the community. By December, twenty-four-year-old farmer Israel Putnam had lost seventy sheep. The townspeople had made several attempts to track or trap the wolf and had even killed her offspring, but the she-wolf eluded them, even chewing off part of one claw to escape a trap that winter.

As the wolf was known to roam the woods west of Putnam's farm, the farmer and five other men kept a constant vigil. One night after a light fall of snow, the wolf attacked again. The men followed her tracks all night to the Connecticut River, backtracking toward Pomfret by morning's light. About three miles from Putnam's farm, seventeen-year-old John Sharp who had followed the bloodhounds before the older men, discovered the wolf's lair, which lay among the granite crags and boulders of a hillside. Once the wolf's location became known, people flocked to the site with guns, torches and materials for smoking the wolf out.

For hours, it was a costly effort. Hounds that were sent in crawled out badly mauled by the she-wolf, and the straw and sulfur lit at the entrance to the den failed to force her from the lair. The men stayed well after darkness fell, but none were compelled to enter the den themselves until Putnam made the decision to crawl in with a rope tied to his ankle, which, at the signal of a kick, would engage the others to pull him from the cave.

He first crawled in with strips of bark used as a lighted torch to ascertain where the wolf lay. Her growls caused the frightened townsmen to drag Putnam from the cave so quickly that his shirt was pulled over his head and his body scratched by the rocks and ice at the entrance. He entered again with his rifle loaded with nine rounds of buckshot and crept farther into the lair than before. Putnam's biographer would later tell the tale:

> *Holding it in one hand and a torch in the other, he advanced farther than before into the den and found the wolf even fiercer, howling, rolling her eyes, snapping her teeth, and dropping her head between her legs. He fired at her just as she was evidently about to spring upon him. Being instantly pulled out, he refreshed himself and waited for the smoke to disappear out of the den. He then made a third venture.*

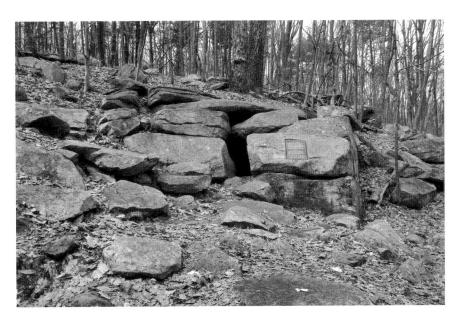

Wolf Den, Mashamoquet Brook Park. *Photo by author.*

When he approached the wolf this time he heard nothing from her and touching her nose with his torch, found that she was dead. He grasped her ears, kicked the rope and was drawn out, dragging his victim into the presence of the astonished and exultant people.

The wolf was carried to a house a mile from the den and suspended from a wooden beam for display while the town held a "wolf jubilee" to celebrate Putnam's accomplishment. The woods where the incident took place have long been preserved as Wolf Den Park, where marked trails lead one to the lair and the brass plaque commemorating the event.

For most of the English who came to settle in North America, the weather was more extreme than they had endured in the old country towns. Even if you had lived on the coast of southern England, the storms of New England were far fiercer in any season, and the winters were especially harsh, with a bone-chilling cold. Lights and unexplained "wonders" often appeared in the sky.

On occasion, these weather events came to be so memorable that Cotton Mather named them "Remarkable Occurences" in his *Magnalia Christi Americana*. It was believed that these events, whether they be earthquakes, floods, violent storms, droughts and even unexplained phenomena were

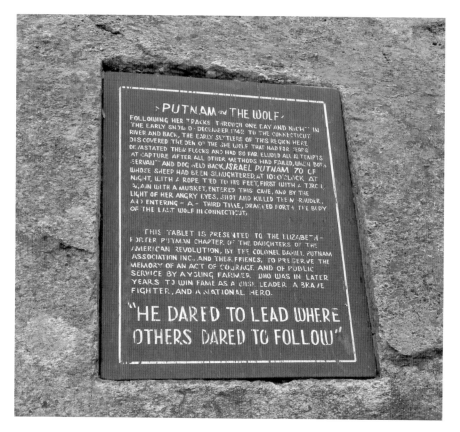

Plaque at Wolf Den commemorating Putnam's deed. *Photo by author.*

brought on the people of New England by God himself, and to each, there was a purpose and a puzzle for Puritan ministers to sort out. Mather collected stories of these events from the earliest diaries and journals of men who were contemporaries of his father and even his grandfather. Their lives and the events through which they lived would be elevated to a nearly mythological status by this third-generation descendant of Puritan ministers.

Some of the events retold from early journals in Mather's work include the following, such as this example from January 1644, when John Winthrop recorded a series of unexplained events around Boston:

> *January 18. About midnight, three men, coming in a boat to Boston, saw two lights arise out of the water near the north point of the town cove, in form like a man, and went at a small distance to the town, and so to the south point, and there vanished away. They saw them about a quarter of*

an hour, being between the town and the governor's garden…and a week after the like was seen again. A light like a moon arose about the N.E. point in Boston, and met the former at Nottles Island, and there they closed in one, and then parted, and closed and parted divers times, and so went over the hill in the island and vanished. Sometimes they shot out flames and sometimes sparkles. This was about eight of the clock in the evening, and was seen by many. About the same time a voice was heard upon the water between Boston and Dorchester, calling out in a most dreadful manner,

"Boy, boy, come away, come away":

and it suddenly shifted from one place to another a great distance, about twenty times. It was heard by divers godly persons.[32]

This was not the first such occurrence in New England, but Winthrop would not have known of the Narragansett tradition of the "tune heard upon the air." Later published as an "Old Indian Hymn," the song is documented as being heard by the Narragansett "and other tribes bordering on the Atlantic coast, many years before the arrival of the whites in America."

Visiting a church in Plymouth Colony after the settlement there, the Narragansett in attendance recognized one of the hymns sung in divine service as the same song they had heard and sung among themselves for generations.[33]

Perhaps the most astounding of the events that Winthrop recorded occurred on June 28, 1648:

There appeared over the harbor at New Haven, in the evening, the form of a keel of a ship with three masts, to which were suddenly added all the tacking and sails, and presently after, upon the top of the poop, a man standing with one hand akimbo under his left side, and in his right hand a sword stretched out toward the sea. Then from the side of the ship which was from the town arose a great smoke, which covered all the ship, and in that smoke she vanished away; but some saw her keel sink into the water. This was seen by many, men and women, and it continued for about a quarter of an hour.[34]

Most journal writers, though no less faith-minded, wrote of the weather and these more unsettling events in a simple, matter-of-fact-way, as did goldsmith and horse breeder John Hull of Boston in 1662:

The former part of this summer was a very great drought, insomuch that the grass and corn was so scorched, there was little likelihood of any harvest,

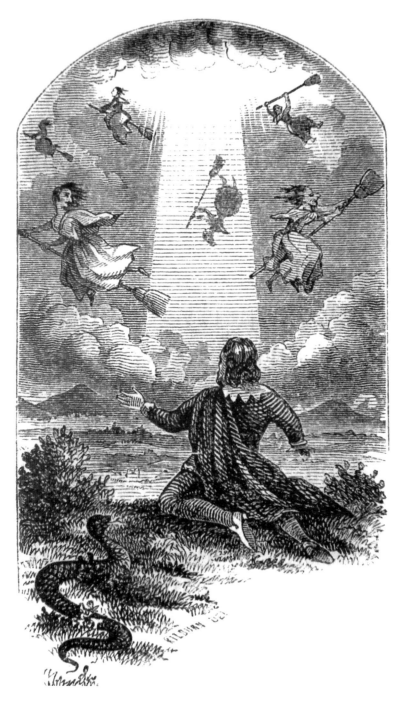

"Puritan Superstitions," as illustrated in this drawing from *History & Antiquities of Boston*.

and so as God seemed to shut out their prayers: but at last, elders being met, in a synodical way, to consult of matters ecclesiastical, they kept one day in fasting and prayer; and the Lord gave a speedy answer, and a full supply of rain and a pretty comfortable harvest.[35]

In July 1665, he recorded another event of biblical proportions:

This summer multitudes of flying caterpillars arose out of the ground and from roots of corn, making such a noise that travelers must speak loud to hear one another; yet they only seized upon the trees in the wilderness... wheat generally blasted, and the blast this year took hold of Connecticut and New Haven; yet the Indian barley, pease, and rye were spared.

The following month brought "a great hail storm; viz, at Linn, Wooburn, and Billirica. Some hail as big as duck's eggs, many as pullets' eggs, divers of them snagged like pike-bullets."

By January 1666, "the frosts were violent," and "Charles River was passed on foot, and only the channel open before Boston." There was a brief thaw, but again in early February, the river was "all frozen again down to the castle."[36]

In October of 1672, Hull would record the event of "a very great easterly storm, and being about the full moon, brought in so great a tide as hath not been seen these thirty-six years; filled most of the cellars near the waterside; flowed more or less into many warehouses; greatly damnified many merchants in their goods and in their wharves; and one vessel cast away in Ipswidege Bay, going to Black Point, and seven persons drowned nearby."

The diarist also recorded a number of remarkable occurrences during his lifetime. During the winter of 1662–63, Hull wrote that there were "several falls of deep snow" between November and February, and then on February 26, "in the evening, about six o'clock, there was an earthquake, that shook much for near one quarter of an hour."

The following winter, "a comet with a blaze appeared about 8th of November and did not wholly disappear till about February." That winter also saw the appearance of "a blazing star" in the last days of November. Hull records that "most of the 11th & 12th mo. was very temperate; little frost, only not much clear sunshine. On the 19th of February, the winter did, as it were, begin again. A cold spring; no tree budded until the 1st of May."

Weather would continue to remain a mysterious provenance in the lives of New Englanders for generations to come and be tethered to biblical

interpretations for nearly as long. Particularly alluring to these early diarists were the occasions of a lightning strike, a particular wonder as this was clearly a direct "bolt from heaven."

In June 1642, John Winthrop would record that:

> *In a great tempest of thunder and lightening* [sic]*, in the evening, the lightening* [sic] *struck the upper sail of the windmill in Boston by the ferry,*[37] *and shattered it in many pieces…the miller being under the mill, upon the ground, chopping a piece of board, was struck dead, but company coming in, found him to breathe, so they carried him to an house, and within an hour or two he began to stir, and strove with such force, as six men could scarcely hold him down. The next day he came to his senses, but knew nothing of what had befallen him, but found himself very sore on divers parts of his body. His hair on one side of his head and beard was singed, one of his shoes torn off his foot, but his foot not hurt.*

John Hull would later record one of these occurrences as well:

> *March 23, 1667*
> *Samuel Rugles of Roxbury, going up the meeting hill, was struck by lightning,—his two oxen and horse killed, a chest in the cart, with goods in it, burst in sundry places; himself coming off the cart, carried twenty feet from it, yet no abiding hurt.*

In 1671, he recorded a similar event that seemed to have biblical connotations, though it is clear he heard the story second-hand: "June 5th…A man in Ipswich repeating a sermon, and because it was darkish, stood at a door or window as a flash of lightening stunned him; but no hurt. His bible being under his arm, the whole book of Revelation was carried away, and the other parts of the bible left untouched."

What we know today as the aurora borealis was an unknown wonder to the settlers in New England. Commonly known as the Northern Lights, this phenomenon long took on meaning as a sign from the heavens. On the evening of December 17, 1719, the appearance of the aurora borealis in Boston created a panic in the city, many seeing the lights as portending the end of the world. Nearly a decade later, minister John Comer of Newport, Rhode Island, wrote of an October night in 1728 when

> *came on the most terrifying awful and amazing Northern light as ever was beheld in New England as I can learn. There was at the bottom of the*

horizon a very great brightness and over it an amazing red bow extending from North to East like a dreadful fire and many fiery spears, and the East was wonderfully lighted and some part of the appearance continued many hours and people were extremely terrified. Words can't express ye awfulness of it. What God is about [to do] *is only known to himself.*[38]

For the majority of communities in early America, however, disease was always the deadliest of predators among them. Unfortunately for many settlers, seventeenth-century medicine had not much progressed beyond the treatments prescribed by medieval doctors. As they would into the early part of the next century, scientists and doctors believed most fever and agues were due to miasmas, or noxious vapors that came from the moldering decay in swamps and stagnant water, the gasses from unburied garbage and, by the close of the century, the fumes from the dead on the battlefields and woods affected by the Indian Wars.

The Pilgrims arrived with a boatload of sick travelers, mostly struck with scurvy for lack of much but a diet of salted meats and crackers. Those hundred or so who went ashore in December 1620 faced a difficult first winter. Governor William Bradford would write in his *Of Plymouth Plantation 1620–1647*:

> *In these hard and difficult beginnings they found some discontents and murmurings arose against some, and mutinous speeches and carriages in others; but they were quelled and overcome by the wisdom, patience, and just and equal carriage of things by the Governor and better part, which clave faithfully in the maine. But that which was most sadd and unfortunate was, that in 2 or 3 months time halfe of their company dyed, espetialy in Jan: and February, being the dead of winter, and wanting houses and other comforts; being infected with the scurvie and other diseases, which this long voyage and their incomusate condition had brought upon them, so as ther dyed some times 2 or 3 a day, in the aforesaid time, that of 100 and odd persons, scarce 50 remained.*[39]

In January 1621, the central house they had built on the settlement "by casualty caught fire," and a number of settlers returned to the ship. By then, Bradford writes,

> *the sickness begane to fall sore amongst them, and the weather so bad as they could not make much sooner any dispatch. Againe, the Governor, and*

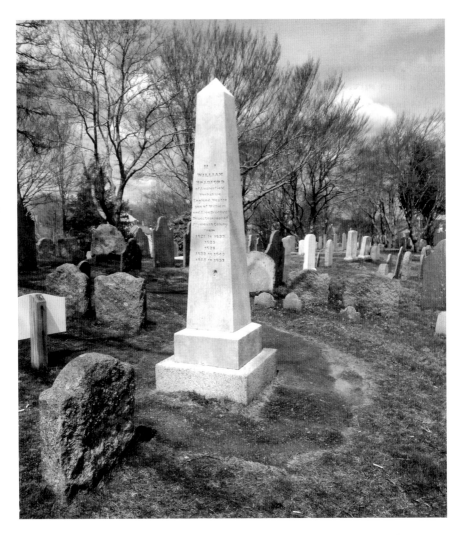

Memorial to William Bradford, Old Burial Hill, Plymouth, Massachusetts. *Photo by author.*

cheefe of them, seeing so many dye, and fall downe sick dayly, thought it no wisdom to send away the ship, their condition considered, and the danger they stood in from the Indians, till they could procure some shelter...The master and seamen likewise, though before they hasted the passengers a shore to be gone, now many of their men being dead...and of the rest many lay sick and weake, the master durst not put to sea, till he saw his men begine to recover, and the hart of winter over.[40]

As it turned out, the feared danger from the Indians was tempered by the meeting with Tisquantum and subsequently with the Wampanoag, who signed a pact of peace with the Pilgrims and almost at once began efforts to aid them in survival, showing them how to plant corn and beans as they did and to build weirs to catch fish for both eating and fertilizing their crops—all methods that the Pilgrims "found true by triall and experience."

Still, the community was to suffer another blow in April when Governor John Carver "came out of the field very sick, it being a hott day; he complained of his head and lay downe, and within a few howers his sences failed, so as he never spake more till he dyed, which was within a few days after."[41] His wife would die but a few weeks later.

Turning again to the diary of John Hull of Boston, his entries show that through the more than twenty years of events recorded between 1657 and 1677, the colony suffered waves of illness nearly as constant as the seasons.

During the summer of 1657, he would record the affect on his own family:

> *My boy, John Sanderson, complained of his head aching, and took his bed. A strong fever set on him; and, after seventeen days' sore sickness, he departed this life.*
>
> *My cousin Daniel Quincy was also cast upon his sick-bed, within a week after the other, and had also the fever, and was brought very low, but, through God's favor, well recovered by the 17th of 8th [mid-August]. My wife was ill when these first began to be sick; but it pleased God, as they sickened she strengthened; and he kept her, and my little daughter Hannah, that then sucked upon her, from any spice of the fever.*

By mid-August, Hull felt ill himself but recovered. A month later, his maid was "taken sick with a strong fever; but the Lord was pleased to restore her to health in three or four days."[42]

In late 1660, another sickness swept the town, and Hull wrote, with relief, no doubt, "Our family was all partakers of the epidemical cold, but, through favor, very gently. Little Hannah lay two days without any mind to play or food. My wife continued four or five days with a great pain in her head and eyes; and most of us one or two days, exercised with pain either in the head, eyes, or throat."

Four years later, Hull would note in a January entry that "about this time began an epidemical cold, and scarcely missed a touch of any; and many people were laid low by it, a fever setting in with it upon many…but it pleased the Lord that few died."

Hull's father would die in July 1666, "being two days before taken with a flux, and then with violent cramp in his legs and burning at his heart." The following fall season and winter would bring the greatest fear to the community: "Dec. 10th, 11th Sam. Paddy fell sick of the small-pox. He went to his mother's house; but there I provided for him...Joseph Green had a very few...Jer. Drummer fell ill of the same disease...Deborah Bell had a few, and, about a month after, had them pretty full."

Most recovered within a few weeks, but then on January 1, Hull would write anxiously, "My wife taken ill of the small-pox, having had about twelve days' trouble with a hot humor in her neck and shoulders; and together with the pox which came, she had much trouble in her head by vapors from matrix and spleen, much impeding sleep, oftentimes fainting of spirits, beating of the heart."

His son and daughter were also taken ill but, all "through the mercy of God," recovered much to his relief. "The Lord enlarge my heart, and all mine, with praise to his great name." Hull wrote when the ordeal was over.

Smallpox during the colonial period was the "most dreaded of the scourges that afflict mankind."[43] Historically, smallpox killed over 25 percent of those infected during an outbreak, often devastating whole communities. There were other troubling illnesses, such as measles, chickenpox, diphtheria, cholera and yellow fever, that could grow to epidemic proportions as well.[44] In late 1672, Hull would record:

> *This summer, very many in most parts of the country, from east to west, from south to north, were taken with agues, and it proved mortal to many...And at the later end of the year, about October, some was thought to have spotted fever in Ipswige, Wenham, and Salem...Sundry persons died in September and October of voiding much blood and some worms, persons of grown age and young men.*

Five years later, the smallpox would return, beginning in December with the death of Mr. Thomas Shepherd, the minister of Charlestown, and continuing through the spring:

> *June 6. A public fast in this Colony. The small-pox since they first began, had seized upon...persons; and about forty persons were dead of that disease. In Charltown, about so many also died since it began there, being in 5th month, '77 to this time. About two hundred persons had had the disease there.*

> *June 22. Mr. Edmund Brown, pastor of the church at Sudbury, died.*
>
> *Sept. 22. To this time, there were about eighty persons of Charltown that died of the small-pox, and about seven hundred that have had the disease.*
>
> *Oct. 3. To this time, there was about one hundred and eighty persons had died in Boston of the small-pox, in a little above a year's space since the disease began.*

Hull records that the disease continued through the fall, taking Samuel Symonds, the deputy governor and the senior pastor of the third church in Boston, as well as three ministers of the nearby communities of Wethersfield and Hingham, among many others. In Woburn in late December, "one David Wyman...taken with the small-pox, was distracted, and ran out of his bed barefoot, in his shirt, five miles to a friends house. There [he] was put into bed, but after died."

Another epidemic illness swept the colony in 1685:

> *The Court having taken into their serious consideration, that in respect of afflictive Sicknesses in many Places, and some Threatening of Scarcity as to the necessary food, and upon other Accounts also, we are under solemn Frowns of the Divine Providence...Do therefore appoint the Sixteenth of July next, to be set apart as a Day of publick Humiliation by Fasting and Prayer throughout this Colony...And do hereby prohibit the Inhabitants of this Jurisdiction all servile Labour upon the said Day.*

As was common in times of any crisis, the Puritans turned to fasting and prayer, seeking forgiveness and divine intervention in healing these sicknesses that many ministers intoned as a punishment from God for their sin. This practice would survive in America well after European nations began experimenting with cowpox inoculations. The practice in the west caused a great stir among the licensed medical practitioners as well, and for decades, medical doctors opposed to the new methods and ministers who clung to Puritan doctrine would share a strange but steadfast alliance that would allow waves of illness to continue to sweep the New England communities for generations.

Another smallpox epidemic hit the colony in 1689–90, and then twelve years later, a siege struck Boston in 1702. The disease was then absent for nineteen years but would come back with a vengeance. Sixteen-year-old seminary student John Comer would write of the epidemic: "April 1721 The latter end of this month the small pox was brought into Boston, which

"Old Store, Dock Square" from *History & Antiquities of Boston.*

was exceeding surprising to me. The first man who brought it in died…the distemper prevailing in town, some of ye youth of my acquaintance were taken away by death."

While many older Bostonians had been exposed to the disease during the earlier epidemics and were thus immune from infection, the smallpox ravaged the very young who had grown in the now prosperous city. As historians Stanley Aronson and Lucille Newman explain:

> *Those younger than nineteen years had never encountered smallpox; and as each smallpox-free day passed, some of the older people with immunity died of unrelated causes while newborns were continually added to the local population of susceptibles. Thus, as the interval between smallpox epidemics lengthened, the fraction of the population with immunity to*

*smallpox diminished, the number of susceptibles increased, and the
likelihood of a major epidemic heightened.*

The disease had been brought into town in April by the British ship
Seahorse when a number of its crewmen became afflicted while the ship lay in
port. Despite frantic efforts to quarantine those infected, by May, the citizens
of Boston were becoming ill, and minister Cotton Mather would note, "The
grievous calamity of the small pox has now entered the town." It was during
this outbreak that the conservative minister would make a significant shift
from the traditional Puritan remedies of prayer and attending of the patient
by a bedside cleric.

This longtime practice of minster as "physician" had occurred, especially
in rural areas, for the simple reason that the clergy member installed in the
community was often the most learned among the residents. Such authority
was not lost on many of the city-bred and educated ministers. When Cotton
Mather intoned his support for the efforts of inoculation, the clergy beyond
the reach and influence of his pulpit refused to be persuaded and continued
to admonish the practice in their sermons and with published pamphlets as
the outbreak progressed. But the clergymen were not the only authority to
resist the efforts to inoculate citizens. Many of the physicians of the time
railed against the practice as well, despite the promising experiments in
Europe and in Turkey. One brave Boston physician named Zabdiel Boylston
administered the vaccine to his own six-year-old son, as well as his "negro
man Jack" and a young African American boy just two and a half years old.
Nearby residents who knew the doctor soon came for vaccines as well. Such
was the outcry over the practice in much of the city that Boylston was nearly
lynched, but of the nearly 250 people the doctor inoculated, only 6 died,
compared to the 800 who refused vaccination and perished.

The stubbornness of the medical authorities, as well as the deeply rooted
beliefs of the clergymen and their influence on parishoners' practices,
would cause years of needless suffering and death in many New England
communities. The argument for vaccinations was also complicated by the
fact that even when inoculated, people still sometimes fell prey to the disease.
The diary of Abby Brown Francis, whose son John Brown Francis would
become governor of Rhode Island, wrote of the boy's illness in November
1798, just months after losing her two young daughters to illness as well. She
chronicled the event of her daughter Anne's death in May of that year when
she wrote, "My dear departed daughter Anne…had just completed 8 years
& 3 months wanting a few days. She was buried by the side of her Father

& sister Sally on May the 23, 1798—Ah little was I prepared for such an Event—The season Opens gaily to all accept myself & to me it only appears to prove that the dawn of Misery is only open to me."[45]

In her pain, Abby Brown Francis wrote what surely many mothers must have felt during those difficult times of illness that swept through every New England community: "July 5, 1798: Yesterday the 4th of the Month was celebrated as usual with the accustom'd Honors due the Anniversary of that day—The Loss of my dear child so recent rendered all of my sensations painful—& circumstances give me little reason to Hope that I can vary much in the course of another year. If Religion refuses me its Aid I certainly must fall a Victim to despair."

Near the end of July, her surviving son, John, was "seized with a violent fever—Vomiting & disordered bowels." He recovered, but fever was apparently spreading in Boston during the fall, for Ms. Francis writes on October 2 that it was the "Third day we have more favorable News of the Fever at Boston." By early November, the dreaded smallpox had visited the region once again: "On this day which is the 14th of Novr & the 8th since my dear Boy was inoculated there appears no evidence of his having taken the Small Pox." However, just four days later she would record:

> On this 18th of Novemr 98 Sunday Morning my dear Boy began to Sicken with the S[mall] Pox. His fever was very high during the day & night, the following morning a Sick Stomach added still more to his uneasiness & distress. This continued till six & twenty hours when the symptoms seemed to abate, in the course of a few hours the pox began very gradually to appear & continued increasing 3 days….Novr the 27th my belov'd child has now I suppose upwards of 3 hundred pock & still sore-low spirited & quite unlike himself—but I flatter myself in the course of a few weeks he will regain his health & become more like himself. God grant I may see him well & happy.

The position of the clergy also meant that legions of young ministers were dispatched into New England towns and villages with the same indoctrination. No matter how learned they might personally become, the church long held them to this timeworn doctrine of prayer and visitation, rather than inoculation, and often upheld the clergy in a supervisory role to the town doctor.

This must have been a singular struggle for young clergymen, being brought into an age with a heightened awareness of science and the growing

progress of medicine in European schools. Even in a well-heeled community, young John Green would find that administering to the sick would be an almost daily part of his duties as minister to Salem village.

On January 2, 1702, the twenty-six-year-old minister would write: "Old William Buckly dyed this evening. He was at ye meeting last Sabbath and died with ye cold [I fear] for want of comfort and good tending. Lord forgive. He was about 80 years old. I visited him and prayed with him on Monday and also ye evening before he dyed. He was very poor, but I hope had not his portion in this life."[46]

In May of that year, he himself felt "very faint and ill and preached with difficulty" at Sabbath. In mid-August, he noted that it was a "sickly time" and visited a Mr. Andrews a few days later who was "very ill." At the beginning of December, we find in his diary: "Dec. 3. Cold. Mr. Andrews dyed in ye night of ye small pox." Green's diary is often sparsely worded, with many entries a single sentence or abbreviated notations. Some entries

Old photograph of the First Baptist Church in Newport, Rhode Island, where Minister John Comer first served as co-pastor. *Courtesy of the Newport Historical Society.*

are spaced weeks or even months apart, though most months of the year hold a few notations.

Minister John Comer's diary reveals that tending to the sick through visits and prayer were an equal challenge to his young ministry in Swansea, Massachusetts, and then Newport, Rhode Island. Having survived a bout with smallpox as a young student, he felt "obliged to serve God in a more eminent manner heretofore, and looking on myself as having ye vows of God lying on me to serve him in ye ways of his Holy Institutions and more especially in ye commemoration of his dying love at his table."

After a short time in Swansea, Comer married a Newport woman and, in February 1726, accepted a co-ministry at the First Baptist Church in the town. On December 21, the twenty-one-year-old minister would write, "This year has been a year of great exercise to me. I have been as it were in a furnace of affliction. The difficulty in my flock has been heart wounding, and almost sometimes confounding, but I see God's grace is sufficient for me."

The young minister was awakened to the hardships of New England life, for during that year alone, in his community, "there were 6 lost, there were 6 drowned, accidentally as some term it, one kill'd with thunder, one kill'd in a well, one found dead with his neck broke."

Comer conducted "missionary work" in outlying towns such as Sutton, Leicester, Middleborough and other places.[47] He also visited and preached to prisoners in Bristol as he continued to work in Newport, administering to his aging parishioners there, conducting funerals and visiting the sick, a task that often taxed him physically as well as spiritually. One entry from 1729 reads: "This day I being sent for to ye almshouse by Mrs. Steadman being ye sick; went and prayed with her. She seemed in great terror about her soul. She expressed great fear of death. O, said she with great anguish, I am afraid to die, I am afraid. O may I have my work well done."

Comer saw outbreaks of fever and agues throughout his years of ministry, as well as the smallpox, which continued its deadly visitations. In May 1729, the minister recorded, "This day the town was mightily alarmed by ye death of a stranger at ye house of Mays Nichols, tavern keeper…it appeared to those yt inspected the body to be ye small of wh he died. By order of authority he was with utmost dispatched buried."

Nichols's wife and a Narragansett servant were dispatched to a quarantined hospital on Goat Island. The tavern keeper's wife recovered, but the Indian girl died. The outbreak placed Comer in a melancholy mood, recording epitaphs from the graves in the common burial ground

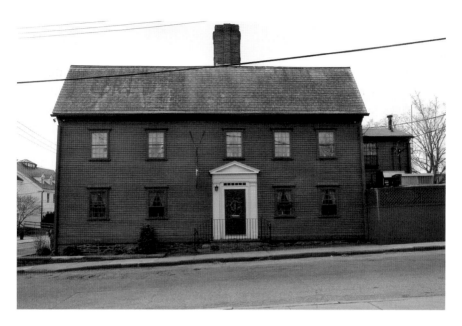

The White Horse Tavern in Newport, Rhode Island. *Photo by author.*

and "a most unaccountable piece of wickedness" that came in news from Block Island:

> *A negro man belonging to Capt. Simon Ray of Block Island being in Newport, in ye heart of ye town, a man being an utter stranger to ye sd negro gave him a letter and charged him to give it to his master himself, which accordingly he did; and upon his opening it it was a blank, with sundry scabs (as is supposed,) taken from some person sick of ye small pox. In surprise he threw it on ye floor immediately, and ye maid of ye house took it up and burnt it. O wt wickedness is lodged in ye heart of man.*[48]

The minister continued in Newport until 1731, recording dutifully those he visited who were sick and dying, the funerals he conducted and the visits with grieving families. John Comer would remove to Rehoboth that year, having contracted consumption, and died less than three years later.

Outbreaks of smallpox would recur in Boston in 1751, 1764 and 1775, though through these years, the idea of inoculation was slowly taking hold. One of the first scientifically minded and influential Americans lent his voice to the debate in 1759 in a written introduction to *Some Account of the Success of Inoculation for the Small-Pox in England and America.* Benjamin Franklin had long

regretted his decision to not inoculate his son in 1736, as he lost him to the disease. Such was the shadow that fell over his life after his boy's death that he promoted the preventative measures vigorously.

Other medical perils came with the vigorous expansion of the China trade and the pursuit of the whale in the Pacific Ocean in the late eighteenth century. Home ports of New England were suddenly exposed to new diseases, of which there were scarcely a clue for a cure.

Yellow fever made its appearance in New England during the late summer of 1797. In Providence, Rhode Island, in mid-August of that year, the schooner *Betsy* anchored on the south side of India Pont and lingered for two weeks. It had come from St. Nicholas Mole in the Island of Haiti, and two men had died with fever during the passage, but the captain kept that from authorities. As the *Betsy* had come upriver, it had taken on Nicholas Windsor of Seekonk, who was on his way to the Providence market with bushels of vegetables. On his return home, Nicholas fell ill and died of a "billous fever" within the week. The crew of the vessel had sent laundry and bedding to be washed at the "long House" at the corner of Wickenden and South Main Streets. Within days, numerous people had fallen ill. By the end of the outbreak, thirty-six people would die. Another sixteen mortalities occurred in Bristol, Rhode Island, with an outbreak the same year.[49] Providence would see recurring outbreaks in 1803, 1805 and again in 1820.

THOUGH THESE PHYSICAL AILMENTS would come to prove a common factor in everyday colonial life, the uncommon occurrence of mental illness rattled the nerves of clergy and common citizens alike. Most cases were individuals whose desperation was borne from hardship—whether poverty or loss of a loved one, though if one had the misfortune to be a widow in early New England, the two often went hand in hand. Such was the case of Margaret Goodwin of Providence, who, in March 1651, was found "in distraction" after the death of her husband, Adam. Six men of the town were appointed to "take care...of Goodwin's wife during her time of distraction." Her possessions were sold to settle her debts, and the remaining goods were given to the town in exchange for her care. Such care seemed to be minimal at best, save for her being allowed to remain in her husband's house, as she was found dead in their home seven years later on March 4, 1657. A "jury" of twelve men were sent to investigate the death and reported to the town assembly, "So neare as we can judge, that either the terribleness of the crack of Thunder on the second or third of the month, or the coldness of the night, being she was naked, did kill her."[50]

The long, cold winters that settlers in New England endured often meant death for those most frail, either from disease as we have seen, or from the effects on a mentally ill person of the bleakness and desolation during those months of snow and ice and an almost constant mackerel sky.

Incidents of suicide appear periodically in the journals of early New Englanders, as in John Hull's diary, when he writes in solemn perplexity, "One Elizabeth Bishop, who had lived, according to visible appearance, both maid, wife, and three times a widow, under many no small trials and now about fifty years of age, in good and very commendable repute for Christianity as well as family and neighborly civility, yet cast herself this morning, as soon as up, into a well; was drowned: all her profession issued in such a snuff."

Samuel Sewall would record these incidents as well, as with his entry of April 4, 1688: "At night Sam Marion's wife hanged herself in the chamber, fastening a cord to the rafter-joice. Two or three swear she was distracted, and had been for some time, and so she was buried in the burying place."[51]

Minister John Comer would also diligently record these unfortunate events, such as a pair of entries during that difficult first year he served in Newport, Rhode Island:

> *Septemr* [1726] *About ye middle of this month one Hannah Suderick, a disconsolate young woman, as is supposed, drowned herself about 11 of ye o'clock at night…And in ye afternoon of ye next day one Catherine Cook attempted ye like action, but was discovered after she had fallen down in ye water; but upon examination before Edward Thirston* [Thurston], *Assistant, and Job Lawton, Justice of ye Peace, she seemed to be under ye power of Satan in a very awful manner.*[52]

In January 1728, he would record, "This night Mary Dye went and drowned herself as the Jewry [Jury] gave it; but most concluded she was murthered by her husband. One of her arms was broke and on yt arm appeared 10 black and blue stripes. She was not found until [incomplete]…If she drowned herself, her husband's ill carriage was the cause."

Of course, it was not only distracted or "disconsolate" women who committed suicide; men also took their lives, more often to escape punishment for wrongs they had done, though some, too, fell into despair for unknown reasons. Samuel Sewall's diary records an incident in February 1723:

> *Saturday, February the First…John Valentine Esq. went out in the morning to speak with Mr. Auchmuty but found him not at home. He staid so long*

Cemetery on Newport's Farewell Street. *Photo by author.*

> *before he returned home that his family grew uneasy, and sent to many*
> *places in the town to enquire after him. At last they searched his own house*
> *from chamber to chamber and closet to Closet. At last Mr. Bowdoin look'd*
> *into the cockloft in the north end of the house, that has no light but from the*
> *stairs; and there, by his Candlelight, saw him hanging.*[53]

The aforementioned minister Comer, then ailing but still serving as pastor of a newly founded Baptist church, recorded on March 27, 1732, "This day in the town of Rehoboth, one Joshua Abel cut his own throat with a razor about sunrise. He had been ill in body for some time."[54]

Whatever the causes that lay at the heart of these self-inflicted deaths, their effect was carried in part by the fears and desperation many felt in the dark period after King Philip's War. Conflicts in the northern territories continued well after the last battle in southern New England. Many of the young women who showed signs of trauma and "possession" to the Salem authorities in 1692 were survivors of Indian raids on the small wilderness towns in the areas we now call Vermont and Maine.

Local violence was increasing as well, as indicated in our previous chapter. How the colonial authorities dealt with this increase of lawlessness and its causes would weave its own blood-dark thread through the fabric of the New England tapestry.

BLASPHEMERS, HEARSAYERS, HERETICS AND INTOLERANT PURITANS

*D*eeply rooted in the American tapestry is the story of a nation founded for religious freedom. First, the Pilgrims fled from religious persecution in Great Britain to Holland and then across the Atlantic, eventually settling at what would be named Plimoth Plantation. A decade later, the ship *Arrabella* entered Boston Harbor under the leadership of John Winthrop, who aspired to raise "a shining city on a hill" that would be a beacon for those back in England, whose faith had long been clouded by the corruption of the Church.

What many Americans do not know is that the first ship to arrive at Plymouth after a disastrous first year was the *Fortune*, which brought more secular-minded immigrants into the Plantation who were seen as largely a nuisance to Governor Bradford. There was little he could do, however, for these men were sent by Thomas Weston, whose company had outfitted the Pilgrims' journey. They arrived with little provisions and sapped the colony of its own. They often lay idle while others worked the fields and used the holidays given to Plymouth inhabitants as times of meeting and prayer to play games in the streets.

By the summer of 1621, the colony had built its first jail, and the arrival of two more ships, the *Charity* and the *Swan*, brought yet more strangers into Plymouth. While some came ashore to refresh themselves before journeying on, others settled within the Plantation or squatted in the woods beyond. Bradford would write with great consternation:

The little store of corn…we had, was exceedingly wasted by the unjust and dishonest walking of these strangers; who though they would sometimes seem to help us in our labor about our corn; yet spared not, day and night, to steal the same it being then eatable and pleasant to taste; though green and unprofitable. And though they received much kindness (from us, yet) set light both by it and us; not sparing to requite the love we shewed them with secret backbitings, revilings, &c.

Eventually, this host of strangers found a place suitable for their own settlement and left for a place the Native Americans called Wessagusset, very close to an encampment of Massachusetts Indians. As might be expected, "They had not been long from us, ere the Indians filled our ears with clamours against them; for stealing their Corn, and other abuses conceived by them."

All that summer, as Plymouth built a new fence around the Plantation— as much to keep the idle men busy as to reinforce or replace what had been built during the winter—word came of the continued decline of the settlement and the demoralizing behavior of its remaining refuges. Bradford would write:

It may be thought strange that these people fall to these extremeties in so short a time; being left completely provided when the ship left them…besides much they

Plymouth Harbor as seen today. *Photo by author.*

got of the Indians where they lived by one means or other. It must needs be their great disorder, for they spent excessively whilst they had or could get it, and, it may be, wasted part away among the Indians…And after they began to come into wants, many sold away their clothes and bed coverings, others became servants to the Indians, and would cut them wood and fetch them water for a capful of corn, others fell to plain stealing, both night and day from the Indians.[55]

In fact, this band of derelicts from England would bring upon the Pilgrims and Wampanoag the first tensions since their agreement of peace and the first organized violence that the English would inflict on Native Americans of New England.

As for the founding of what would become Boston, for what visions Winthrop and others might have of a spiritual city, even among the devout there were divisions, and aboard the *Arrabella*, were speculators, sailors, servants and sinners of all types come to inhabit the settlement. If Congregationalists were hopeful of establishing a group of colonies united in religious devotion, they were badly disillusioned. As historians Chris Beneke and Christopher Grenda point out, "In North America, no comparable religious settlement was ever attained. Instead, the situation varied from colony to colony and over time, with some of the basic ground rules of ecclesiastical order frequently at issue."

Congregationalists may have established themselves in Massachusetts and Connecticut, but even there they were challenged by local Anglicans who disavowed their legal authority. While authorities at first established an adaptation of English law, there being no separation of church and state, religious authorities established far-reaching codes of law in each settlement. Chief among these were codes that forbid the expression of difference or discontent with church authorities or doctrine.

Games and dancing were banned on the Sabbath, as was work itself, though livelihoods among the poor were difficult even in the best of times. In that first year in Boston, John Baker was whipped for shooting fowl on the Sabbath day. Thomas Morton, another man known to scorn the Sabbath, was thrown in jail and his house burned, and he was then returned to England for his "many injuries to the Indians and other misdemeanors." Among those misdemeanors was a severe dislike of the hierarchal structure of the ruling authorities, which he penned in his book *New England Caanan*, a scathing rebuke of Massachusetts policy.

In June 1631, Winthrop recorded, "At this court one Philip Ratcliff, a servant of Mr. Cradock, being convict…of most foul, scandalous, invectives

against our churches and government, was censured to be whipped, lose his ears, and be banished [from] the plantation, which was presently executed."

The punishment was considered by many to be so severe that it made notice in the British newspapers. Later that year in September, "one Henry Linne was whipped and banished, for writing letters into England full of slander against our government and orders of our churches."[56]

So how did it come about that these refugees from a corrupt and unjust church established an equally authoritarian rule and, in many respects, a harsher government in the New England colonies? Bradford in Plymouth had established a civic rule, and any disputes were addressed and settled within the overlapping jurisdictions of town meetings, church congregations and courts of law. This bond between citizens, however, soon became challenged and then overwhelmed by the flow of immigrants who swelled the settlement and then quickly moved on to establish other towns.

In the island-pocked harbor that all but surrounded the settlement of Boston, John Winthrop arrived with a charter authorizing him to establish "a

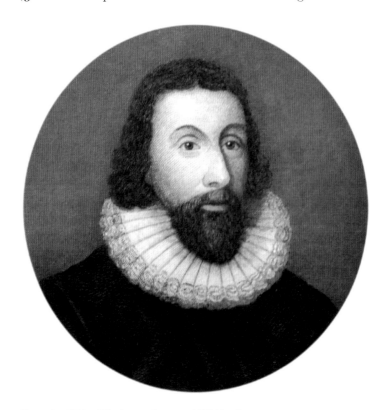

Portrait of John Winthrop. *Courtesy of Wickimedia.*

solemne assemblie" that would make up a "great and generall courte," which was allocated complete jurisdiction. The charter granted by British authorities stipulated that the colony could establish any rule of law so long as it did not conflict with English law. The impact that Winthrop and others' actions had in establishing this early rule of law in America is still much discussed and debated today.

Legal scholar David Thomas King engenders that in establishing a system of law in the colonies, both in Virginia and Massachusetts, that "the basic contours of English law and the self-conscious elevation of its importance…persisted and survived transplantation." He attributes the severity of the law during this period to a "near obsessive concern," after leaving a homeland in crisis, "with using the law to achieve security of property and reestablish social order."[57]

Other scholars, however, argue that Winthrop looked far beyond English law to the Bible itself in establishing an Old Testament–like authority and that Massachusetts in particular "adapted English legal categories only if consistent with the Bible and used scripture as the direct source for roughly half of their criminal law." Church members were heavily favored for the Assembly, reaching half the membership by 1652.

The colonies of Massachusetts, New Haven and Connecticut would grow to be the "most vigorous in adapting criminal codes against heresay, blasphemy, and other religious offences in the first half of the 17th century." New Haven magistrates declared from the onset that "the worde of God shall be the onely rule to be attended in ordering the affayres of goverment in this plantation."[58]

The immediate impact of biblical influence on civil law as we have seen, was the intolerance of any member of the community contesting church doctrine or forwarding ideologies of their own to a gathered assembly. Thinkers and ministers worshiping under the umbrella of Puritanism held widely diverse opinions on how the church in the new colonies should be formed, as well as the tenets that ministers taught the congregations to follow.

Roger Williams was one such thinker. Having come under the guidance of Sir Edward Coke in England, Williams arrived in Boston in 1631 as a confirmed Puritan teacher. For five years, he labored in Boston and Salem in the field and also in the pulpit when congregations would take him on his own terms.[59]

Williams's views stirred controversy in Salem and more so in Massachusetts, colonies from which he would eventually be banished. As a thinker and a writer of no small stature, Williams held steadfast to his beliefs in the face of the Puritan

Statue of Roger Williams with his signature beneath. *From* Illustrated Rhode Island.

authorities, though he was not averse to amending them with time.

It seems that his most ardent hope was that church doctrine would prove to be more fluid in the colonies and open to ideological debate on its growth as it took root in this new Eden. Indeed, historian Glenn Lafantasie observes that the banishment from Massachusetts deeply affected Williams, and he carried it with him all his life "like a wounded veteran."

One of Williams's pronouncements was that the land that the English claimed rightly belonged to the Native Americans and any claims to such title were surely a sin and could only be repudiated by commissioning a new charter that admitted as such. Williams also opposed the government's enforcing biblical teaching, especially when it came to the first four of the ten commandments. While many Puritan ministers appear to have agreed with him in principal, they allowed the imposed punishments for blasphemy and failing attendance in local churches to continue well into the eighteenth century.

Massachusetts authorities meant to return Roger Williams to England when the ruling for his expulsion from the colony came to pass, but the minister had been informed by Governor John Winthrop that authorities were coming for him in Salem, and he fled to the woods, living among the Wampanoag before establishing a settlement on the east bank of the Seekonk River in what is now East Providence, Rhode Island. Informed by Edward Winslow that his settlement was still under Massachusetts jurisdiction, he was advised by Winthrop to head across the river and

establish a plantation in Narragansett lands, where he might live in "friendly neighborly relations."

Williams did much more than that, establishing the colony of Rhode Island and offering a haven for those persecuted on religious grounds, as well as the first experiment in the colonies of the separation of church and state affairs.

Williams had not been long expelled from Massachusetts when authorities were dealing with another popular dissenter in the form of Anne Hutchinson, a woman whose family had followed minister John Cotton to Boston. Hutchinson was "a woman of kind heart and practical capacity of various kinds"[60] with a keen intellect and a fiery spirit and was soon admired by other women and men alike.

Cotton had stirred his church congregation, admonishing his fellow ministers for straying from church doctrine and bringing a revival of staid Puritan belief—namely that God had chosen to give grace and salvation to a select group of individuals who would discover that grace within a conversion experience. He said that such predestination trumped any efforts of prayer and "holy living" that ministers encouraged in their congregations with the hope of a genuine conversion. Hutchinson and others believed that such a reliance on good works was a defection from Puritan belief to those of Catholicism or Dutch Protestant ideology.

Her outspokenness to the authorities and the meetings held within her own home led to accusations of antinomian (or lawless) teachings—a charge that held little merit as she had never denounced ministers for preaching the force of moral law but rendered it deemed by God, though whether one obeyed the law or not did not have a bearing on one's chances to enter heaven. As she and her followers challenged the teachings of ministers in Boston and in neighboring towns, their struggle became political when some followers refused to serve in a regiment led by a chaplain who was one of their fiercest opponents against the Pequots during the first of the Indian Wars.

Massachusetts authorities banished some followers for that transgression and disenfranchised others while drawing up a list of "errors" for which they would eventually place Anne Hutchinson on trial. Hutchinson defended herself vigorously but erred in the court's eyes when she declared that she had followed Cotton to Boston through a "divine revelation" in which it was shown to her that "she would suffer, but would be delivered like Daniel had been from the lion's den."

Church doctrine taught that the last direct communication from God to humans had come during the writing of the book of Revelations. No modern prophets or mystics wandered the earth, and the "word of God" could only

Monument to Hutchinson & Dyer, Portsmouth, Rhode Island. *Photo by author.*

be deciphered by those chosen authorities. Thus her pronouncement of divine revelation was used to banish her from the colony.

Within a short time, the Hutchinson family, along with eighty other religious dissenters, sought refuge in the new colony of Rhode Island, where Roger Williams, despite his own misgivings about her beliefs, helped the group, which included Quakers led by William Coddington, to purchase what would become known as Aquidneck Island.

Among these new settlers in the town they called Portsmouth was one Samuel Gorton, who joined those called the Antinomians after being expelled from Massachusetts. As historian James V. Sydney noted, "Gorton called himself simply and grandiloquently 'professor of the mysteries of Christ,' but he was regarded as a Familist, a forgotten term that once chilled the blood of the ordinary Puritans."[61]

He believed that mystical communication with the Holy Spirit was not only possible but also that it was his very life's calling. While not a follower of the early mystic movement of Dutch theologian Henry Nicials, Gorton's beliefs were similar, and his personality, seen by his enemies as "cocksure, jaunty, and pugnacious," was but one side of a man who, by all accounts,

riveted audiences with his teachings and displayed "the greatest tenderness toward his friends and neighbors."

Those neighbors soon grew familiar with Samuel Gorton's habits of wandering long hours in the woods to commune with God and nature. He was a holy-minded predecessor of Thoreau but one who would find little acceptance beyond his small community of followers. He soon ran afoul of authorities on the island, and on August 1, 1640, Roger Williams would write to John Winthrop:

> *Master Gorton, having foully abused high and low at Aquedenick, is now bewitching and bemadding poore Providence…All suck in his poison, as they first did at Aquednick. Some few and my selfe withstand his Inhabitation, and Towne privilages, without confession and reformation of his uncivill and inhumane practices at Portsmouth. Yet the tyde is too strong against us, and I feare…it will force mee to little Patience, a little Isle next to your Prudence.*[62]

The hostility shown them by authorities in Providence led the group—by now termed the "Gortonites"—to establish a settlement in Pawtuxet, but neighbors there were equally hostile. The group then purchased a large swath of land from the Narragansett Indians, but this soon came into dispute among the Shawomet and Narragansett sachems. The Shawomet natives appealed to the Massachusetts authorities, and when Gorton failed to appear at a requested hearing, he was arrested, along with several others, and sentenced to hard labor in Massachusetts. Within a short time, however, authorities learned that his teachings among his fellow laborers were stirring unrest and released him from his sentence but barred him from his settlement or any other land under the Bay Authority.

Gorton managed to travel to England and obtain protection for his purchase of Shawomet from the Earl of Warwick, and while there, he penned an account of the wrongdoings of authorities against himself and the Shawomet settlers.

With the Gortonites finally allowed their own land, contention between neighboring settlements lessened, and they resumed life much like any other hardworking Puritan community. This included "what functioned as a town church, although in principle they resolutely organized no congregation, exerted no ecclesiastical discipline, and rejected any sort of partnership between religion and the secular community."[63]

With his life settled, Samuel Gorton would serve diligently in the colony's assembly and earn the respect of many who had once been wary of his

teachings. He maintained a good relationship with the Native Americans who remained around Pawtuxet and other places along Warwick's shore, as well as inland on Cowesett.

Samuel Gorton had taught his followers that he was but a medium through which the Holy Spirit communicated and that any number of them might also achieve this communion, but as historian Sidney James wrote, "His personality proved in the end to be the sole source of unity." After their leader's death, the Gortonites drifted into Baptist and Quaker communities, but some remained steadfast to his teachings long after the memory of the man had faded. Perhaps the last of these followers was John Angell of Providence, who once showed a visitor three books written in Gorton's hand and told them that these were "written in heaven, and no man can understand them unless he was in heaven."[64]

These individuals who were singled out aside, the sect that authorities in Massachusetts and Connecticut came to revile most was the Society of Friends, derisively called Quakers, which first entered the Bay Colony in 1655. In July of that year, Ann Austin and Mary Fisher arrived in Boston Harbor on the *Swallow* from the West Indies, having been cast out of that country for their beliefs. The women immediately drew suspicion from the authorities. A year later, when eight more women arrived and shared the pair's dwelling, authorities arrested the women and carted them off to jail. Fisher and Austin reportedly called out to the crowd following them in the cart to repent, for "a day of howling and sad lamentation is coming upon you all from the Lord."[65]

Quakers came with zeal to the New World, convinced that the passionate and often eloquent expression of their beliefs, coupled with their work as missionaries to the poor and disenchanted, would come to oust the moral superiority of Puritan authority. But as historian Juliette Haines Mofford explains:

> *For Massachusetts and Connecticut, the coming of the Quakers represented a major crisis of law and order. Members of this religious sect refused to take the oath to support the Crown, or to bear arms to protect New England from her enemies, and they would not pay taxes…this troublesome sect respected no human authority and considered women equal to men, even permitting them to take an active role in worship services.*

Authorities deported the ten women, but Quaker missionaries continued to arrive in the colony. In September 1659, John Hull would record the arrest of

Founders Brook, where Hutchinson and friends first found refuge in Rhode Island. *Photo by author.*

> *three Quakers…William Robinson, Marmaduke Stevenson, (2 young fellows, little above 20 years of age)…and one Mary Dyer of Rohd Island, who about twenty years since, was of Boston, and brought forth a hideous monster, part like a man, part like a fish, part like a bird, part like a beast, and had no neck: it had scales, claws, and horns. These three persons had the sentence of death pronounced against them by the Genrall Court…and well they deserved it.*[66]

Mary Dyer was reprieved from the sentence by late October, though the young men were executed. Hull's description of the unfortunate stillbirth that Mary Dyer endured speaks to her notoriety in Boston. Dyer had been a close friend of Ann Hutchinson, and she and her husband, William, had stood by her in court when she was banished from the colony. Hutchinson had been present at the birth of the deformed child and, on the advice of her minister, John Cotton, agreed with Jane Hawkins, the midwife, to keep the incident a secret from authorities. A third woman who had arrived at the Dyer household during the birth and saw the remains of the child informed Governor John Winthrop by March 1637 that Mary Dyer had

given birth to "a monster." Winthrop immediately summoned Miss Hawkins and persuaded her to confess the details of the birth. He summoned Cotton as well and, after remonstrating him for his part in the concealment of the incident, seems to have accepted his apologies. He may have believed, as Roger Williams seems to have believed, that all parties involved had likely been influenced by the exiled Hutchinson. "Mrs Hutchinson (with whome and others of them I have much discourse) makes her Apologie for her concealement of the monster that she did nothing in it without Mr Cottons advice, though I cannot believe that he subscribes to her Applications of the parts of it," Williams wrote.

Winthrop and Puritan authorities would use the tragedy to stir up fear of those Antinomian followers to illustrate the punishments that God dealt to those who clung to false doctrine and the Familist path of direct communication with the divine.

Mary and William Dyer returned to England with Roger Williams in 1652 to obtain the charter for Rhode Island. William returned with the founder the following year while Mary stayed and fell under the influence of the Quakers.[67] Her return to New England in 1657 alarmed authorities, and while she was remanded from death, she was banished to Rhode Island.

In the first session after the expulsion of Mary Fisher, Ann Austin and the other Quaker missionaries, the General Court in 1656 enacted laws specifically aimed to curb the further arrival of sect members. These included:

- a fine of £100 against any shipmaster knowingly transporting Quakers into the colony and imprisonment if he refused to return them to the port from which they had sailed
- a like fine for anyone importing, concealing or distributing Quaker books in the colony
- an immediate sentence for any convicted Quaker to the house of corrections, where they were to be "severely whipped, and by the Master there be kept constantly to work and none suffered to converse with them."[68]

Other laws enacted established fines for anyone defending the Quakers or criticizing the government's punishment of them. The Bay Colony also enacted a law that stifled the Quaker practice of publicly criticizing officials by imposing a punishment of public whipping and a fine for anyone "who shall revile the office or person of magistrates or ministers."

Such was the distaste with which Massachusetts authorities held the sect and their persistent efforts to convert citizens that the court enacted even tougher laws in the coming years. In 1657, it was rendered law that male Quakers, on their first arrest, should have an ear removed before being sent

to the House of Corrections. A second arrest would result in an "H" for heretic being branded on the hand, and a third meant "the tongue would be bored through with a hot iron before he was banished again."[69]

By 1659, the court ruled that any Quaker having been twice expelled from the colony who returned to "test the laws" was to be executed. This ruling set the stage for the return and martyrdom of Mary Dyer.

John Hull of Boston recorded in his journal the events in March 1660: "Mary Dyer came audaciously through the town at high day. All her private friends that met her persuaded her to return. She answered, she had a strong power to go forward, but no strength to go back…She was by authority apprehended."

Mary Dyer was hanged in Boston on April 1, 1660. Three other Quakers who had accompanied her were "banished upon pain of death." The hanging of Mary Dyer seemed to stir the blood of authorities even more and set off a resurgence of anti-Quaker persecution that extended even to innocent or sympathetic innkeepers who "entertained" members of the sect in their houses. By 1676, the General Court had issued authority to local sheriffs to seek out and arrest any Quakers within the Bay Colony.

Elsewhere in New England, authorities from the colony of New Haven frequently whipped, branded and imprisoned Quakers. Those who escaped imprisonment were banished. Women were severely whipped after their second offense. In New Haven in 1658, two women received forty lashes each for teaching that "infants were not cursed with Adam's sin until they themselves had sinned."

It was only in Rhode Island that New England's Quakers and other religious dissenters found a refuge, much to the disdain of John Winthrop, who had bristled from the outset as "liberty of conscience," or an individual's right to worship as their conscience dictated, had been established in the colony.

Winthrop wrote in his journal in 1639, "The devil would never cease to disturb our peace" and, specifically, "At Providence…the devil was not idle. For, whereas at their first coming thither, Mr. Williams and the rest did make an order, that no man should be molested for his conscience, now men's wives, and children, and servants, claimed liberty hereby to go to all religious meetings."

Though Roger Williams had voiced his dislike of the Quaker doctrine, the colony he founded was indeed based on a separation of church and secular affairs. No one was expelled for their religious beliefs so far as the secular laws of the colony were followed. The ideological debate concerning the Quaker doctrine was put forward by Williams in correspondence and in his pamphlet criticizing the teachings of the sect's founder: *George Fox Digged Out of His Burrows.*

Friends Meeting House in Newport, Rhode Island. *Photo by author.*

Williams believed that Fox and the Quakers had severely misinterpreted John 1:9 and that their misunderstanding of divine light meant that such light "shone in every man, rather than making the…distinction that it shone ON every man, with only some actually receiving it."[70]

Williams would harshly admonish the Quakers for their belief, writing that they were borne "out of ignanimous pride," and continued the debate with Fox on paper but never persecuted any member of the sect on religious grounds.[71] Quakers, in fact, thrived in Rhode Island, with many becoming wealthy merchants in the coasting trade and prominent citizens in many Rhode Island towns. They succeeded in building a complex network of spiritual and business partnerships among friends and to take an active role in civic life, elevating those earlier efforts by activists and martyrs into action and civil law. By 1670, they made up half of the membership of the colony's general assembly. Historian Sydney V. James wrote, "Quaker officials as far as one can tell, felt scrupulously bound to act for the whole colony, and injected their special principles, such as pacifism, into public affairs in no doctronaire fashion. They rejected the use of oaths and the expensive pageantry of government normal in the 17th century, but these were hardly controversial matters in Rhode Island."[72]

The sect also made converts even as persecution reached a fever pitch. When Cassandra Southwick of Salem was fined for skipping meetings at the Salem church, it was found that her husband, John, and their three adult children had all become converts to the Quaker doctrine. The elder Southwicks fled to New

Saylesville Meeting House in Lincoln, Rhode Island. *Photo by author.*

York, but the younger were jailed after refusing to pay the thirty-shilling fine levied on each of them for missing "six Sabbathday meetings."[73]

Quakers also found converts in Rhode Island among the many dissidents who had settled in the colony. Historian James notes, "Quakerism gathered most of the Rhode Islanders inclined toward mystical Christianity, as contrasted with those who rejected all thought of direct communication with God and sought religious truth by for the most exact reading of the Bible."

The last Quaker martyr hanged in Boston from those "devoted droves" that continued to arrive in the Massachusetts Colony was William Leddra. The Quaker had spent a year in Plymouth's prison and had been expelled from Essex, as well. In Boston, he would spend a year in prison chained to a large log, which he was forced to bear with himself into court in the early spring of 1661. The Boston court offered him liberty to leave, but William Leddra was determined to be a martyr and told the court that he was willing to die for the truths he had spoken. The court thus sentenced him to death, and Leddra was hanged on March 14, 1661.[74]

With the restoration of Charles II to the throne in England, the numerous complaints from the persecuted Quakers in the colonies finally received notice and resulted in the decree that prohibited the use of corporeal

First meetinghouse in Providence. *From Field's* State of Rhode Island and Providence Plantations at the End of the Century *(1901).*

punishment against the sect. While this set back colonial authority, the Massachusetts Court still managed to legalize the whipping and carting of Quakers in 1662, and numerous communities still persecuted members of the sect. It was not until the Royal Charter of 1692 that liberty of conscience was granted to all Protestants in the colony.

Such liberty of conscience, however, was late in coming for many in the colonies. While historians have mainly focused on the religious struggles of the period—and indeed, the colonies were a hodge-podge of beliefs and persuasions—besides the dissenting and often unbending communities of Anglicans, Baptists, Anabaptists and remaining Puritans, colonial beliefs were also borne of folklore, home medicine, Native American beliefs and spiritualism.

Historian Sydney V. James observed, "The novelties offered to slake their spiritual thirst were religions that anywhere else would have been considered as old, traditional, and conservative in contrast with the eccentric sects nurtured around Narragansett Bay."[75]

Cotton Mather would write scathingly of Rhode Island in his *Magnalia Christi Americana:*

I believe there never was held such a variety of religions together on so small a spot of ground as have been in that colony. It has been a colluvies of Antinomians, Familists, Anabaptists, Antisabbatarians, Arminians, Socinians, Quakers, Ranters, every thing in the world but Roman Catholics and real Christians…I may venture to say, that Rhode Island has usually been the Gerrizim of New England. The Island is indeed, for the fertility of the soil, the temperatures of the air, the commodiousness of scituation, the best garden of all the colonies; and were it free from serpents, I would have called it the paradise of New-England…If I should now launch forth into a narrative of the marvelous lewd things which have been said and done by the giddy sectaries of this Island, I confess the matter would be agreeable enough…for a warning unto all to take heed, how they forsake the word of God and his ordinances in the societies of the faithful, and follow the conducts of the new lights, that are no more than so many fools-fires.

But often hidden beneath the struggle of the religious hierarchy for authority is the story of those without power and those who resisted obedience to any authority. Historian Perry Miller claimed that from the outset, less than one-fifth of the adult population of Boston "could give such evidence of their sanctification as would admit them to a covenant of a particular church."[76]

By the time of the new charter in the Bay Colony, many had strayed altogether from religious conformity. Parts of the New England colonies were exceedingly lawless places, and corruption was rampant in local courts, whose wealthy, landowning appointees gave local citizens little justice. The populace in cities, as well, was largely described as wayward and fallen into vice and lewd behavior.

As early as 1642 in Plymouth, an aging William Bradford would write despairingly that for all the colonies' severe punishment, authorities "could not suppress the breaking out of sundry, notorious sins…especially the drunkenness and uncleanness. Not only incontinency between persons unmarried…but some married persons also. But that which is worse, even sodomy and buggery (things fearful to name) have broke forth in this land oftener than once."[77]

By the end of the seventeen century, Cotton Mather would write of Boston, "'Tis' notorious that the sins of this town have been many sins, and mighty

sins; the 'cry thereof hath gone up to heaven' if the Almighty God should from heaven rain down upon the towne a horrible tempest of thunderbolts, as he did upon the cities 'which he overthrew in his anger and repented not,' it would be no more than our unrepented sins deserve."[78]

Chapter 4

CRIME AND PUNISHMENT IN THE COLONIES

\mathcal{A}s we have seen, from the very beginnings of the settling of New England, there was a struggle to maintain law and order. While many made the journey from England and other countries to escape persecution, they soon found themselves saddled with an equally authoritarian rule. A severe lessening of morals came to settle on the colonies, for despite the propped-up façade of Puritanism and its aggressive pursuit of those perceived as a threat to church authority, the Assemblies had lost all connection with the hardships and despair many felt in the towns, especially in the rural areas of Massachusetts and Connecticut.

From the time immediately following King Philip's War to the advent of the Great Awakening was, in many respects, a very dark time in New England's history. Drunkenness was a vice brought over with others from European ports, but it flourished particularly in New England, where first Native Americans were sold alcohol by European traders and then the settlers themselves succumbing equally to the ravages of liquor. The court dealt with drunkenness as it did with other crimes in the early colonies, as when the Massachusetts Court dealt with one Robert Cole, who, "having been oft punished for drunkenness," was sentenced to pay a hefty fine as well as wear an embroidered red *D* about his neck for a year.[79]

Local drunks became a common sight in the colonies despite the harsh measures meted out by the authorities. On July 16, 1687, Samuel Sewell would write in Salem that the previous night had seen "a great uproar and Lewd rout in the Main Street by reason of drunken raving Grammar Flood,

came from about Wheeler's Pond, and so went by our house into town. Many were startled, thinking there had been fire, and went to their windows out of bed between nine and ten [o'clock] to see what was the matter."[80]

A decade later, Cotton Mather would sermonize in *Boston's Ebenezer* of the need to curb access to the ordinaries and taverns in the town:

> *Oh! That the drinking houses in the town might once come under laudable regulation. The town has an Enormous Number of them: will the Hauters of these houses hear the counsels of Heaven? For you that are the town dwellers, to be oft or long in your visits to the ordinary twill certainly expose you to mischief's more than ordinary…when once a man is bewitched with the ordinary…he is a gone man: and when he comes to die, he will cry out as many have done "Ale-houses are hell-houses. Ale-houses are hell-houses!"*

Most colonial towns delivered punishment for drunkenness with time in the stocks and treatment similar to that of Robert Coles. Fines ranged from five shillings in Salem to twenty shillings for habitual drunkenness in Connecticut, where an offender would be whipped if he or she could not pay the fine. Eventually, names of common drunkards were ordered to be posted on ordinary and tavern walls. Those keepers and traveling salesmen of "strong drink" faced heavy fines if they supplied liquor to those deemed "common tipplers."[81]

Other early forms of punishment followed the favored approach of public humiliation. The "High Chair" was often used for drunkenness, raising the offender strapped to an armchair, tied to a rope and tackle, above a jeering crowd of witnesses. Likewise, the "Ducking Stool" was a favorite punishment for women by 1672. This consisted of an armchair fastened to the end of two beams and hung on an axle. The device was supported by a post set beside the bank of a pond, or river, with the chair suspended above the water. The offender would be placed in the chair and plunged into the water "in order to cool her immoderate heat."[82]

Lewd or at lease loose behavior was often a result of drunkenness. In 1634, the Boston Court fined one Captain John Stone £100 for "drawing company to drink" and threatening Mr. Ludlow after showing up inebriated in court for the charge of "being found upon the bed in the night with one Barcroft's wife."[83]

In the Essex County Court in 1655, the suit for slander and defamation of character by Christopher Avery against his former friends James Standish and William Vincent revealed that the men had been in company drinking

"The Stocks." *Illustration from Drake's* History and Antiquities of Boston.

strong liquors and had "drank so long that they could not tell ink from liquor." The men caroused and broke bottles in the alehouse while Avery "dangled another man's wife on his knee, as ye foolish man, her husband, looked on."[84]

The first pair of stocks was built in Boston by 1639, though the practice of "sending one to the bilboes" had been brought from England in a few communities, as when Cambridge imposed the sentence on James Woodward in August 1672 for "being drunk at the Newetowne." A heavy bolt of iron with two sliding shackles, the stocks locked the offender's legs to the bar with the shackles for the period determined in the sentence. Cursing, speaking against the authorities or "selling peeces and powder and shott to the Indians" could get one sent to the bilboes in those early villages and towns.[85]

Salem soon earned as notorious a reputation as Boston for such behavior. While their standing as mercantile towns with harbors open to the world

might lead one to believe this a plausible cause for such a reputation—and no doubt many brawls occurred between those in the taverns—it is the behavior of the locals that often stands out in the records.

In 1674, Samuel Sewell would record a pair of disturbing events that bookmarked a trying year in the colony. On April 2, 1674, he recorded the case of "Benjamin Goad of Roxbury, (being about 17 years of age) was executed for committing bestiality…he committed the filthiness at noon day in an open yard. He after confessed that he had lived in that sin for a year."

As the government lived by the biblical tenet that "If a man lie with a beast, he shall surely be put to death; and ye shall slay the beast," the mare with which Goad committed buggery was clubbed to death before him as a prelude to his own execution.

But such shocking behavior was not unheard of in the colonies. In fact, one of the most infamous cases had occurred in 1642 when seventeen-year-old Thomas Granger faced a jury after admitting to Plymouth authorities that he had committed such acts numerous times with at least a dozen animals. On the afternoon of September 8, Granger was forced with others to watch the slaughter. Governor William Bradford recorded "the sad spectacle" in his journal: "First the mare, and the cow and the rest of the lesser cattle were killed before his face according to the Law, and then he himself was executed. The cattle were all cast into a great and large pit digged of purpose for them, and no use was made of any part of them." The colony of New Haven had hanged three men for committing bestiality between 1635 and 1662.[86]

By the close of 1674, Sewell's entry would highlight another deviant act more commonly occurring in the colonies. On December 25, the judge recorded that "Sam Guile of Haverill ravished Goodwife Nash of Amesbury, about G. Baileys Pasture at the White Bottoms."

Puritan authorities in the earliest years of the colonies had spent an inordinate amount of energy enforcing the sanctity of marriage among the people and even encouraged parishioners to keep an eye on courting couples. If witnessed in the act of "carnal copulation," both man and woman were punished. At times, the parents were punished as well. Both Massachusetts and Connecticut had passed acts by the 1630s that no man could court a woman without her parents' consent. This law did little, however, in preventing meetings at gatherings away from the church, such as barn raisings, the collective gathering at harvest or the periodic "trayning days," when the young men drilled for the town's militia.

As historian Juliet Haines Mofford points out, "Puritan and Pilgrim authorities believed that due to Eve's rebellion against God and temptation

Courthouse in Plymouth, Massachusetts. *Photo by author.*

of Adam in the Garden of Eden, women had less self-control over mind and body than men" thus "females were more easily tempted by carnal desire and morally weaker in resisting sex than males."[87]

A common fine for fornication was forty shillings, though Rhode Island was often more lenient, with the General Court of Trials fining Howlong Harris of Providence five shillings after her testimony that she had become "so surprised by drink that she was unable to resist the temptation to 'fornicate' with Thomas Deney."[88]

As fair-minded as the colony may have been in leveling affordable fines on both men and women convicted of fornication, it nonetheless brought numerous inhabitants into court on those charges. During the session of October 1679, the case of Sarah Comby, accused of "fornication committed with Henry Timberlake," shared the docket with that of Mary Allen, accused of the same with wealthy landowner Rowland Robinson. Both Comby and Timberlake were found guilty and sentenced "to be whipd with fifteen stripes or to pay the sum of forty shills to the Gen. Treasury."[89] Timberlake willingly paid the eighty shillings for himself and his partner. The court cleared Rowland Robinson, he having pled "not guilty" in an earlier appearance and, having "not been appeased" by that court's decision, brought the case before the court again, but this time his accuser failed to show.

Repeat offenders received harsher punishment, and as Mofford's work says, "Women, particularly servants, were punished more severely than the males with whom they coupled, especially if they bore an illegitimate child, and particularly if they dared to accuse their masters."

The tragic result of many of these affairs or illicit unions was to be infanticide. The shame of having a bastard child, the public humiliation that the woman could expect to endure for her sin and the stigma the child itself would bear in its life were often cause enough for young mothers in Puritan New England to end such a life just minutes after giving birth.

In December 1646, twenty-two-year-old servant Mary Martin gave birth to a daughter in the back room of Widow Borne's house in Boston, where she had been employed throughout her pregnancy. The child's father was a married man of Casco Bay, one Mr. Mitton whom her father had entrusted with the care of Mary and her sister. According to John Winthrop's account, "He was taken with her, and soliciting her chastity, obtained his desire, and having divers times committed sin with her."

Mary had tried to conceal her pregnancy, but "her time being come," she attempted to kill the child immediately after birth, but hearing it cry out again, she "used violence to it till it was quite dead." Mary placed the body in a chest and then cleaned the room and went to bed. A week later, when the Bornes boarded a ship to England, Mary removed herself from the house and found another boarding home. When a suspicious midwife confronted her, Mary confessed to giving birth but said the child "was still-born, and so she put it into the fire." The authorities were called and Mary's room searched, where the chest was found with the infant's body still inside. She was brought to jury and forced to touch her dead child's face, "whereupon the blood came fresh into it."[90] She was thus convicted by her own confession and this "ordeal by touch," an archaic remnant of medieval law resurrected in colonial New England.

Mary Martin was hanged on March 18, 1647. Winthrop left no word as to whether the man who had seduced and ultimately sealed her fate for his own pleasure was ever punished in any way.

Late in 1670, Mary Ball of Watertown, Massachusetts, would find herself in similar circumstances. Coming from a broken family and entrusted to the care of one Michael Bacon Jr., she, too, succumbed to her master's advances and became pregnant. She fled from Charleston Harbor to Rhode Island, where her cousin had married into the Bayton family of Portsmouth. Bacon had apparently promised to send money, but as the weeks passed and no word or support came, she could hide the pregnancy no longer and

confessed to Francis Brayton that the child she carried was "begotten by Michael Bacon…and no other man."

Brayton traveled to Waterown to deliver a letter from Mary, pleading with him to keep his promises, writing, "You only on Earth knows [*sic*] how things were at the first with us." But her former master denied responsibility, and Brayton took the letter to authorities. Mary's absent father also pressed charges against Bacon for transporting his daughter out of Massachusetts without his authority. Michael Bacon was thrown into jail but escaped, leaving deputies to watch the bridges that led out of Cambridge and Watertown. Within a few days, he was back in custody and hauled before the court, where he posted a "bastardy bond," agreeing to support the child.[91]

Elizabeth Emerson of Haverhill gave birth to a daughter on April 10, 1686. She named the child Dorothy and told the midwives attending her that the father of the child was her handsome neighbor, Timothy Swan. The young man's father, however, would have no part of his son facing a charge of fornication and threatened Elizabeth with taking her to court for slander if she formally accused him of fathering the child. Elizabeth's sister Mary had been fined for fornication three years earlier, and Swan told authorities he had forbidden Timothy to enter "that wicked house" and sent his son away to work with his brothers while the talk in town quieted over time. Elizabeth relented and raised her daughter in her grandparents' home.

Five years later, however, authorities were knocking on her door, seeking to question her concerning several town midwives' suspicions that she had been pregnant yet again and already given birth. Elizabeth was forced to undergo examination by the midwives, and their conclusion, as given to Chief Magistrate Nathaniel Saltonstall, confirmed those suspicions. A search yielded a shallow grave behind the house that contained two infant bodies without any sign of violence on their bodies. One had the umbilical cord twisted around its neck. The midwives concluded that "both died at time of travail for want or care."[92]

Elizabeth confessed that she had kept the pregnancy from her family and had given birth on her father's bed. Though she told the magistrate that "I never did murther those babes," she confessed to having sewn the bodies in a sheet, placed them in a drawer and waited for her father to leave and her mother to go "out milking" in order to bury the children in the yard. As shocking as the crime was to local authorities, equally shocking was the name she put forward as the father.

Samuel Ladd was the forty-two-year-old son of one of the town's founders. He was a married man and father of eight children when Elizabeth made her

claim. Because of his wealth and standing, the magistrate never questioned him, and he was never accused of adultery. Elizabeth, however, was whisked away to Boston where she was placed in prison for two years before being hanged for her crime. Winthrop notes that she shared the gallows that day with "Grace, a negro," who had also been convicted of killing her child.

So common had the practice become that in 1692, Massachusetts would petition the King's Privy Council to establish "concealing the death of a bastard child" as a capital crime:

> *Whereas many lewd Women that have been delivered of Bastard Children, to avoid their Shame, and to escape Punishment, do secretly Bury or Conceal the Death of their Children…Be it therefore enacted… that if any Woman be delivered of any Issue of her Body, Male or Female, which if it were born Alive, should by Law be a Bastard, and that they endeavor privately, either by Drowning or secret Burying thereof…In every such case, the Mother so offending, shall suffer Death, as in Murder, Except such Mother can make proof by One Witness at the least, that the Child whose Death was by her so intended to be concealed, was born Dead.*[93]

Such suspicions of infanticide would shadow single, pregnant women for generations to come. It was certainly on the minds of the twelve men who, in October 1725, were sent to investigate the death of a male child "borne of the body of Ethalanah Steere of this Towne of Providence." The appointed jury questioned the mother and, having "made deligent search upon the said childes body" found no marks of violence or abuse, concluded that "our judgement is that the said child was dead born: and that it might be by Reason of a fall that the said woman had of from a horse as shee said shee had sum few days before."[94]

Behind the Puritan attempt to lawfully honor the holy vows of matrimony was an increasing loosening of chastity behind the church's back or at least beyond the blind eye cast by authorities. Crimes against women increased at the close of the seventeenth century when widows of lost soldiers and sailors and both married and single, free-spirited women abounded in the colonies.

The wariness such authorities held against such women can be seen as early as March 1643, when Mary Latham was brought before the Boston Court along with James Britton on charges of adultery. She denied having sex with the accused but named a dozen other partners she had while married to her elderly husband, including two married men of the town.

Latham and Britton were summarily convicted and executed, despite a last-minute plea on Britton's behalf.

At the biannual court held in Robert Mendum's tavern in Kittery, Maine, in October 1651, the gathered judges considered, among other local cases, that of Joan Andrews, described as "an infamous scold and breaker of the peace." On this first court appearance, Mrs. Andrews was charged with committing adultery with one John Diamond, her married neighbor. Though the court could not find enough evidence to convict the pair, they were ordered to avoid each other's company. At the same court session, Andrews was fined forty-five shillings for "abusing the Governor." Had she refused to pay the fine, the court was prepared to punish her by laying "25 stripes upon the bare skin."

The following year, Joan Andrews faced charges of "abusing Goody Mendum," having made "many approbrious speeches" against her, including stating that she was an "Indian whore." Mrs. Andrews had apparently learned of an incident in Mary Mendum's past; thirteen years earlier, she had been convicted of adultery with an Indian and was "whipped through the streets of Duxbury and sentenced to wear the letters 'AD' on her sleeve as a badge of her shame."[95] Mendum was now the tavern keeper's wife, and she had faced charges the year before for "abusing Mrs. Gullison in words," the wife of Hugh Gullison, a new tavern keeper in Kittery. Still, despite the claimant's reputation, the court rendered a guilty verdict and ordered Joan Andrews to receive "twenty lashes…upon the bare skin." That same year, she was implicated by her neighbors for another unseemly relationship with a married man. In this case, her alleged partner, Gowan Wilson, was brought before the court for "frequenting the house of John Andrews suspiciously at unseasonable times and for his daily accompanying…Joan Andrews up and down the Piscataqua River about frivolous occasions, whereby the said Wilson doth neglect his own wife, children, and family."

In 1653, she was in court again, sued by brewer Rice Thomas for slander, assault and battery. If those charges weren't enough she made "many threatening and reviling speeches" against the judges before she eventually admitted her guilt to these and other charges. On this occasion, the court ordered a punishment of public humiliation, ordering her to stand for two hours during town meetings in both York and Kittery "with her offense written upon a paper in Capital Letters pinned upon her forehead."

In June 1674, housemaid Hannah Downing accused Samuel Leonard of Lynn, Massachusetts, of attempted rape. A "skilled hammers-man" in the iron trade and under contract with his brother Thomas to manufacture iron

for the Rowley Iron-Works in Ipswich, Leonard pleaded not guilty and told the court that Maid Downing's complaint "had no cause" and was merely made out of malice. Several witnesses on Hannah's behalf painted a different picture of the Leonards. Sarah Bates testified to "seeing the Leonards abuse Hannah and pull off her head-cloth." Goodwife Symonds also testified that Sam Leonard had come to her house asking for beer. When she went to the cellar to draw him an ale, he had followed and attempted to kiss her.

According to her testimony, Elizabeth Symonds admonished him, saying, "There are maids enough for you to kiss…You do need not come here to kiss married women." In response, Samuel Leonard had "struck a blow on the small of her back."[96]

Leonard was never convicted, and he and his brother left Ipswich in the fall after a fire of suspicious origin burned the Rowling Iron-works to the ground.

The usual penalty in the Bay Colony for rape was a public flogging, though the sentence was mainly left to the judge and jury to decide. Often men were let off with a lenient sentence, though in 1681, one William Cheney of Dorchester was hanged for "Carnal Copulation with a maid by force against her will." In the colony of Connecticut, rape was only punishable by death if the act was committed against a married woman. All other cases were at the discretion of the court to administer "some grievous punishment." A typical conviction of rape in the colony, and also in New Haven, was to brand convicted rapists with an "R" on their cheek.

Given this treatment of women in the Puritan age, it seems safe to assume that many crimes against them, particularly rape, were seldom reported. In the journals of the period, we often find only the grim aftermath of the crime recorded, as in John Winthrop's entry for the June 4, 1648: "The wife of one Willip of Exeter was found in the river dead, her neck broken, her tongue black and swollen out of her mouth, and the blood settling on her face, the privy parts swollen etc., as if she had been much abused, etc."

While murder was a rarity in early New England, some incidents of the crime, such as the one listed above, went unsolved. Such was the transience of people in the early colonies that one could quite easily have gotten away with committing the crime and then slipped away from the local jurisdiction. On occasion, if the prison or courthouse were some distance from where the crime occurred, the accused never showed in court.

Such was the case in Providence in January 1660, when the prostrate form of John Clawson was found on a footpath that ran adjacent to the burial ground from the Towne Street. Clawson had been brutally bludgeoned in the face and chest with a broad axe and spent several hours after being found

View of the Hunt River as it runs beneath the Post Road in Kingston, Rhode Island. *Photo by author.*

in a state of delirium, given wine and sugar at the home of Roger Williams while he "spake by fits and could not answere a word to many questions."[97]

While many in town suspected rival landowner Benjamin Herndon of being a principal in the murder,[98] town officials arrested an itinerant Native American and, having no formal prison, enlisted the aid of blacksmith

Henry Fowler to forge a set of irons to bind the prisoner. They kept him thus chained in the Mowry Tavern, close by the scene of the crime.

Roger Williams and Valentine Whitman interrogated the suspect and obtained a "confession," and the town assembly ordered that "the prisoner Waumanitt shall be sent down unto Newport to the Collony prison there to be kept until his tyme of trial."[99]

A longboat was obtained and two townsmen selected to escort the prisoner. The men were given a pint of liquor, as well as "powder and shott to carry along with ye prisoner." The three set off from Providence, but there is no record to indicate that they ever arrived in Newport. Many in town believed this reaffirmed Herndon's role in the killing and that the disappearance was orchestrated as a cover-up to the crime. Authorities in Providence held other suspicions as to the fate of the men and prisoner, as demonstrated by their consideration in May 1660 to "build a prison among ourselves," as "the Town of Newport being so farr From us that wee cannot with small charge transport prisoners in the best time of the yeare, and not without manifest danger in the winter season."[100]

The first execution for murder in the colonies occurred in Plimouth in 1630. The case was duly recorded by William Bradford when "John Billington the elder…was arraigned, and both by grand and petty jury found guilty of willful murder, by plain and notorious evidence." The family held some notoriety in town, being "one of the profanest families amongst them." The elder Billington had argued with young John Newcomen and later "shot him with a gun, whereof he died."[101]

In the colony of Connecticut, only three people had ever been brought to court on charges of homicide before 1660, and the first public execution took place there in 1667. One of those convicted was Benjamin Tuttle, who, after a heated argument with his sister Sarah on November 17, 1676, returned to her small home in Stamford with an axe, where he struck her on the right side of her head for her to be found later by neighbors "laying dead across the hearth with her head in the cornar of the chimney…barbrusley Slayen in her one hous," the axe left laying in a pool of blood by her side.

Such incidents were still rare, however, and in the next thirty-three years, only six others were hanged in the colony for murder. Historian Ava Chamberlin demonstrates that half of the murders were household crimes: Peter Abbot had slit the throats of his wife and child in Fairfield in 1667, Henry Green of Farmington had knocked his neighbors child on the head with an axe in 1675, and in 1678, John Stoddard of New London killed his infant stepbrother with a blow on the head and then killed his neighbor and

two children after she refused his request to spend the night and "bid him be gone…gave him A blowe with her hand and shut the Dore."

Chamberlin would write, "Of the conditions conducive to violence in this period, intimacy was the most lethal. Large households shared small spaces, and neighbors were constantly in and out of one another's homes. With little privacy in the home or at the work place and no place else to go, people lived constantly in the same small group. Such frequent contact caused conflict, which on occasion escalated to murder."

Another common denominator was the choice of weapon—the axe. The axe, after all, was a common household tool, and colonial homes often held several of varying sizes and weight. As Chamberlin notes, "Because the household fire needed continual care, wielding an axe was a skill everyone learned at an early age." These axes were used to split kindling, chop wood and fell trees; they were also used on early farms to kill. As much as the gathering of wood was necessary for the early New England household, so was the slaughter of cattle and swine for provisions. The very phrase "knocked on the head" to record these murders refers directly to the practice of slaughtering animals, and the popular admonishment of a murderer as a "butcher" comes from this period as well.

Without question, however, the crime with the most potential to inflict the greatest harm on people and property in the colonies was arson. The Massachusetts General Court made arson a capital crime in 1652 for anyone beyond the age of fifteen "who willingly and maliciously burned a dwelling house or public building, barn, mill, malt house, storehouse, shop, or ship."

Fire was often the community's greatest fear, as everyone living in seventeenth-century settlements could attest.

John Winslow would record on April 6, 1645:

> *Two great fires happened this week, one at Salem; Mr. Downing having built a new house at his farm, he being gone to England, and his wife and family gone to the church meeting upon the Lord's day, the chimney took fire, and burnt down the house, and bedding, apparel and household to the value of 200 pounds. The other was at Roxbury this day. John Johnson, the surveyor general of the ammunition…having built a fair house in the midst of town with divers barns and other out houses, it fell fire in the day time, (no man knowing by what occasion,) and there being in it seventeen barrels of the country's powder and many arms, all was suddenly burnt and blown up, to the value of 4 or 500 pounds. The fire began with many people inside who had first fought the flames, then, thinking of the powder,*

Illustration of Native American. *From Thompson's* History of the Indian Wars.

fled the house, and soon after, the powder…blew up all about it, and shook the houses in Boston and Cambridge, so as men thought it had been an earthquake, and carried great pieces of timber a great way off and some rags and such light things beyond Boston meeting house…[102]

Boston would suffer a near catastrophic fire in 1653. Twenty-three years later, a young Samuel Sewall, being oblivious of that event, would record that on the morning of November 27, 1676, "Boston's greatest Fire brake forth at Mr. Moor's, through the default of a Taylor Boy, who rising alone and early to work, fell asleep and let his Light fire the House, which gave fire to the next, so that about fifty landlords were despoyled of their Housing."

In this period, with the memories of the Indian raids on New England communities still fresh in the minds of citizens, fire became a growing concern, not only from the remaining Indians who sometimes sought vengeance but also from slaves and indentured servants who might take such measures to settle some dispute.

Essex County took arson so seriously that it charged young servant Henry Stevens in November 1641 for "carelessly firing the barn of his master." He was sentenced to serve John Humfry for an additional twenty-one years. In September 1652, Edith Craford was indicted for the act that she did "willingly and feloniously fire the dwelling house lately your husband's in Salem and more lately belonging to Captain Thomas Savage or Anthony Ashby."

Mrs. Craford fervently denied any such act, and witnesses soon testified to the ire Mr. Ashby seemed to have toward her, who had said that she "was a witch, and if she were not a witch she would be one" and that it were best to hang her for the fact. The jury found in Mrs. Craford's favor, and Ashby was later sued by her family. Such was the concern that even wishing a neighbor's property harmed was cause for punishment. In 1647, Ann Hagget was fined for wishing "the Curse of God" on one Rice Edwards, "that fire might come down from heaven and consume his house"; the result being that lightning had struck Goodwife Ingersoll's barn.

Beyond these punishments, however, there was little authorities could do to prevent the determined arsonist, usually working under cover of darkness, from carrying out the crime.

John Hull records a worrisome series of events in Boston that occurred less than a year after the fire of 1676. On January 9, 1677, "A Candle was fastened on the roof of a house, and burndt through the roof, yet was prevented from spreading through the wonderful providence of God; but the authors not known."

Less than three months later, on March 12, 1677, "A barn of John Usher's burdnt down about 10 o'clock in the night. The houses round about her preserved. The authors not known." And then on June 8, "a like endeavor to fire the town in Mr. Usher's lane. The hay in a barn fired, but being salt

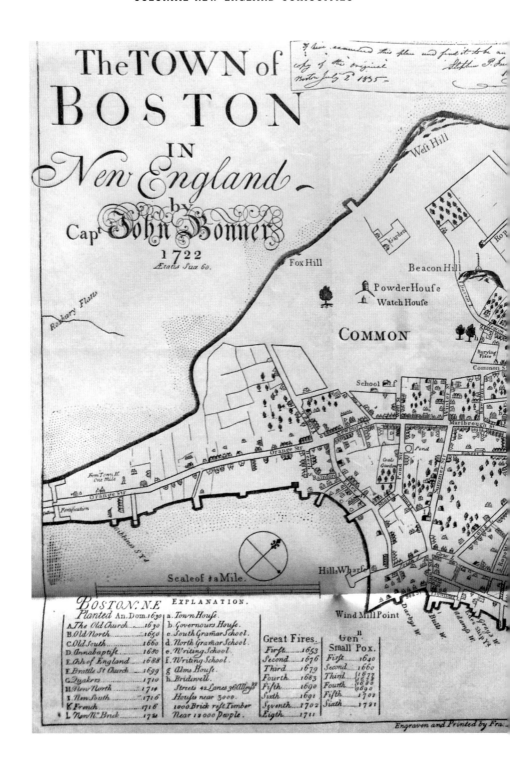

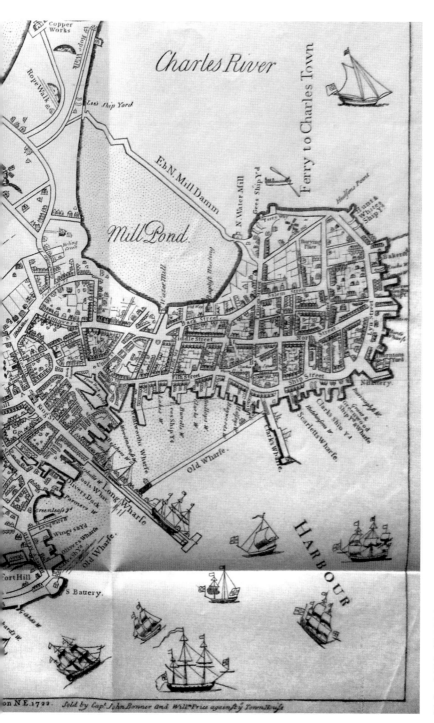

Map of
Boston
in 1722.
From
Historic
Towns
of New
England.

marsh hay, it smothered, and did not hastily burn. About eleven o'clock at night, it was quickly quenched."

On August 6 of the same year, "A candle lighted [was] found stuck between the little houses of Mr. Brandon's, in Mr. Shrimpton's lane, about ten o'clock at night."

The diary of John Hull shows that on May 8, 1679, "a fire kindled under Captain Ben Gillam's Warehouse [was] surmised by most to be done on purpose to fire the town." The next night, around midnight, the house of tavern keeper Clement Gross was "set on fire in an out room." The blaze was quickly extinguished, but as in other cases, there was "no author to be found."

No more incidents occurred through the summer until August 8, when "about midnight began a fire in Boston, an alehouse, which by sunrise, consumed the body of the trading part of town."[103]

In 1711, another record fire swept Boston, destroying nearly one hundred houses, including some of the grandest and most elegant buildings constructed up to that time. Both sides of the Cornhill district of the town were swept away by flames, and the First Church and Town House were lost, as well as "the upper part of King Street, and the greater part of Pudding Lane."[104]

Minister John Comer would write that the cause of "ye great fire in Boston" was "a drunken woman living near ye meeting house" who "carelessly set some oakum on fire, and so fir'd her house, etc."

Comer would record as well that on the evening of April 22, 1727, in his parish town of Newport, Rhode Island, "a train of combustible matter was laid under the floor of ye Old Church porch, and set on fire, but was timely discovered so [that] little hurt was done by it. It was a very evil act."

Despite much evidence to the contrary, authorities believed that the greater number of crimes were committed by transients and vagrants. For this reason, strict measures were taken by some communities as early as 1630. As historian Mofford explains, "New England towns had the legal right to determine whether or not newcomers would be permitted residency within their borders. It was the selectmen's right and duty to exclude undesirable strangers or any outsiders expected to end up as public dependents."[105]

In 1639, the town of Hartford, Connecticut, established a law that any citizen entertaining "one not admitted an inhabitant in the town" was legally responsible for any costs incurred by their guest during their stay. New Haven was to pass a similar law in 1656, with an added provision that no one could remain in the town for more than a month without the written permission of the local magistrate or a vote from the freemen.

By 1680, Rhode Island, which had for over forty years been a refuge for religious dissenters, found itself also overrun with indigents and other refugees, as the Assembly notably addressed in its meeting on October 17 of that year:

> *Votted. Whereas it hat beene of latter times frequent for strangers to shroud themselves within this jurisdiction from ye justice of ye law in [our] neighbor colonies: and for ye prevention thereof heare and for ye future, this towne hath now chosen Richard Arnold and John Whipple Jun[ior] to draw up an order against such processing's of such persons among us, and present it to ye towne at ye next towne meeting.*[106]

Strangers were then ordered to appear before the town assembly and give an accounting of their business. If a stranger failed to do so, the action was swift and severe. That same year, authorities in Providence sent notice to one

> *Margaret Russell being a non-resident here, and having no consent of this towne nor colour of Law heare to abide, that you forthwith depart out of ye jurisdiction of this sd. towne, within foure or six dayss at ye uttmust, or otherwayes ye towne shall see cause to send you to ye next cunstable at Rehobeth/ or to ye place of your former abode/ and of this you may assure yo[ur] selfe.*[107]

Seven years later, the town issued an order for one Thomas Waters and an unnamed woman brought with him "who is like to be troublesome to our towne, and in likelihood burthensome." The town had summoned Mr. Waters to appear and provide "securitie…to save ye town indemnified from [what] charges at any tyme may accrew upon ye towne through his meanes." Waters had refused to cooperate and instead "Reflected upon ye towne with Apprascious termes."

The town sheriff was ordered to "Remove ye said Thomas Waters and ye sayd woman and all of his charge out of this towne."[108]

Prisons, of course, were the last resort for vagrants and citizens resorting to petty crimes, but they were altogether necessary for those capital crimes that were committed, and so in many communities, these were built shortly after the initial settlement. Boston constructed its first prison in 1632. The "stone prison," as it was called, sat in the center of town, surrounded by a stockade fence. By 1640, the Massachusetts Court had reviewed prison reform and established that each county in the colony construct its own

Providence's first prison. *From Field's* State of Rhode Island and Providence Plantations at the End of the Century *(1901).*

"House of Correction." These were establishments that were intended to offer the inmates education and job training but were often constructed at the edge of town and used to implement hard labor upon the prisoners. The colony of Salem built its first House of Correction in 1663.

Connecticut also adopted the policy, ordering a House of Correction to be built for "the detyning keeping of such to their due and deserved punishment," and by 1667, jails had been constructed in every county. By 1701, the colony was maintaining four large prisons.

As we have seen, Providence had first considered a prison as early as 1660, but conflicts over sites and cost kept any proposal from passing. Finally, at the town meeting in February 1695, the General Assembly ordered a prison to be constructed "near the water's side, next [to] Gideon Crawford's warehouse."[109] At the meeting in April, the location was changed, but a general "tumult amongst the people" caused the matter to be dropped again until 1698, when thirty pounds was afforded to the cost of building a prison. It was finally completed by 1700 but burned to the ground less than five years later.

A new prison was constructed on the same site, reputedly on the west side of Benefit Street, and remained until 1733, when the colony built a new prison on William Page's lot, which stood on the north side of the road, leading to the ferry at narrow passage. The road acquired the name of Jail Lane, but this was changed to the present Meeting Street. A fourth prison was built in 1753 on a lot granted by Providence to the state that adjoined the cove-basin in the city and stood partly over the water. This building was used for interment of prisoners until the turn of the nineteenth century.

What was really needed at this time was reform to the laws that imprisoned so many. Massachusetts prisons were overflowing with those accused of witchcraft during the winter of 1692. When the debacle of those trials and the suffering of prisoners was exposed to the monarchy, a new charter was imposed, and the Puritan authority was replaced by civic law in the colony, though remnants of this authority lingered on in Connecticut into the mid-eighteenth century.

THE LAW IN THEIR OWN HANDS

*R*hode Island had been the first colony to experiment with a government free of the constraints of any faith, that "liberty of conscience" that John Winthrop had seethed about in his letters. It was a daring endeavor, though as Judge William J. Staples would write, "There existed in this little community, a great distrust and jealousy of delegated power. Experience had forced them to have recourse to it, and they endeavored to provide against its abuse, by the frequency both of general meetings of the whole body, and of the elections of their offices."

Such a system based on self-governance, of course, has its weaknesses, and we know also that many abused "liberty of conscience," as Staples wrote, "to the point of licentiousness." There were some who claimed to have the right to do as their conscience dictated and denied the magistrates any power to judge their behavior, as Samuel Gorton had done when he stood before the men he dared to call the "just-asses" of the court.

Though many papers have been lost from that early period, we know that in November 1638, the governing body in Newport declared that, by election, "Nicholas Easton, Mr. John Coggeshall, and Mr. Brenton are chosen and called unto the place of eldership, to assist the Judge in the execution of justice and judgement for the regulating and ordering of the offences and offendors, and for the drawing up and determining of all such rules and laws...under God, which may conduce to the goode and welfare of the commonwele."[110]

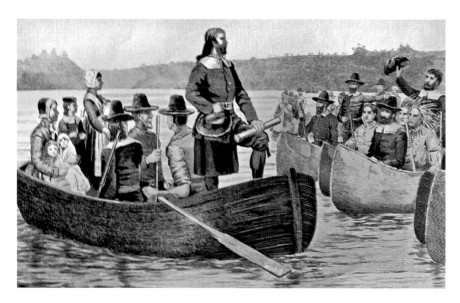

Nineteenth-century illustration of Roger Williams returning with the charter, which allowed the colony to be "a lively experiment." *From* Illustrated Rhode Island.

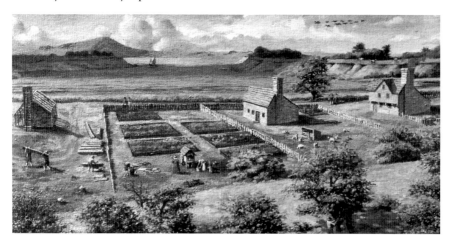

Scene from early Providence. *Courtesy of the Roger William Memorial Park, Providence.*

On November 24, the body voted "as necessary for the commonwealth, that a constable and sergeant be chosen by the body to execute the laws and penalties thereof."

The body also ordered the constable to "keep the prison," which seems to have been the sergeant's office, and to "hand such who will be committed unto his custody with all safety and diligence."

In 1639, Jeremy Clarke was chosen "constable for one whole yeare, or till a new be chosen."[111] The following year, it was decided that "all Particular Courts, consisting of the magistrates and jurors shall be holden on the first Tuesday of each month in Providence, Newport, and Portsmouth."

In 1640, a code of law was enacted in Providence under the oversight of "Five deposers," men chosen by the Assembly, which included the following provisions:

> *wee agree if any o' Neighbours doe apprehend himselfe wronged: by these: or any of these: five deposers: y' at the Generall Towne metting hee may have a Triall…That if any person damnifie any man either in Gooded or Good name: and the person offended follow not the cause upon the offender that if any person give notice to the five deposers; they shall call the partye delinquent to Answere by Arbetration…ffor all the whole inhabetance to combind ourselves to assisst any in the pursuite of any partye deliquent with all o" best endeavors to at[t]ach him.*[112]

While laws were placed within the books, enforcing them was another matter, and too often, it was little matter to local authorities. Then in May 1647, representatives of the diverse population that had settled in the colony came from Providence, Portsmouth and Newport to become joined under a single charter and held a momentous General Assembly to organize the government and its judicial system.

The government consisted of a president, one assistant for each town, a general recorder, a public treasurer and a general sergeant. Judge Staples summarized the judiciary for the lay reader: "The President and assistants composed the General Court of Trials. They had jurisdiction over all aggravated offences, and in such matters as should be, by the town courts, referred to them as too weighty for themselves to determine."[113]

The "Generall Lawes," or "5 Heads of Law," as the Assembly also termed them, were in abbreviated form, as follows:

> *Under the head of murduring Fathers and Mothers being ye highest and unnatural…are comprehended those lawes that concern high treason, pettie treason, rebellion, misbehavior, and their accessories…*
>
> *Under the law for manslayers…self-murder, murder, homicide, misadventure, casual death, cutting out the tongue or eyes, witchcraft, burglurie, robberie, burning of houses, forcible entryes, rescuous and escape, riotts, routs, and unlawful assemblies, batteries, assaults, and threats…*

Under the law of whoremongers those that defile themselves with mankind...sodomie, buggerie, rape, adulterie, fornication...

Under the law of manstealers...lawes that concern theft of men, larcenie, trespass by man or beast, fraudulent dealing, forging or raising records, writs, deeds, leases, bills, etc.[114]

The General Court met twice a year, and "all questions of fact" were determined by a jury of twelve men. Town courts had first jurisdiction over cases within their own boundaries.

Apparently, court hearings were often tempestuous and sometimes even violent, for in 1655, the Assembly passed a law forbidding anyone from striking another in court for fear of being whipped, fined or both, "according as the court shall meet."

Also that year, Providence recorded in its "book of brass clasps":

The Progress in Law its first tenet being that All actions and cases shall be tried by six townsmen in the nature of a jury, yet with the liberty of not being put on swearing; and these six men to be picked by the town quarterly, and warned three days before the court, by the Sergeant, to be ready at the day and hour appointed, under penalty of three shillings for their neglect.[115]

In 1656, the body made the experience of self-governance even more implicit when it enacted a law declaring that "all the inhabitants, though not admitted freemen, were able to be elected to office" and liable for a fine if they refused to serve.

Jury duty, as we know it today, was a far more sobering assignment in early Providence. To be called to be among those freemen chosen to decipher the facts and consider the case that should go before the General Court meant that an individual was summoned to investigate in the event of any violent assault, robbery or death within the community. Escorted by the sheriff and his assistant, the men were taken to the scene of the accident or crime, and evidence found by the sheriff was viewed, as was the scene itself. Interviews with witnesses were conducted that day whenever possible, and one member of the group was chosen to record the testimonies and views of the twelve with regard to the case.

One of the first inquests recorded in the "book of brass clasps" of Providence was the suspected robbery of Widow Sayers. The suspect was named Wesuontup, a Native American of Mashpaug, near the present Providence/Cranston line. According to the indictment, Wesuontop had

"ffelloniously ma[d]e an escape from the hands of his Keepers" some months before and that around midnight on April 18, 1649, he had broken into "the house of Widdow Sayers and took out thence severall goods &c."

The suspect pleaded not guilty, and on the June 19, 1649, those assistants serving the town at that time—Thomas Harris, Robert Williams, Thomas Olney and Joseph Greene, as well as the interpreter Christopher Hawkshurst—presented their findings to the grand jury after interviewing witnesses and informants.

During their first "Examination" of Wesuontup, he told the men:

> he came from massaapauoge with an other Indian called Nanheggen yesternight into this Towne, and that he came to work with Mr. Scotte; That hewith the said Nanheggen lay that night on the other side of the River…That the said Nanheggen tooke a Lader from Nic: powers house, to goe in, at a hole of Widdow Sayers house. That the said Nanheggen went in…and did put out of the said house, at the said hole, a Coat of skine, and three loaves of bread.[116]

Nanheggen had only then opened the door for Wesuontup and sent him inside to "fetch fire, to take a pipe of tobacco." After some prodding, the suspect indicated that another Native American named Paugaucuttucoe could vouch for him.

When interviewed, however, Paugucuttucoe told the assistants that he had "come to this Towne last night alone, for Wesuntupe, to helpe him lance a Cannow [canoe] but he could not find him."

Interpreter Christopher Hawkhurst also testified that Paugucuttucoe had "came the last night unto Roger Williams house to iquire for the said Wesuountup, but he was not there." Nanheggen was brought before them the same day "upon o foresaid hue & Cry" to give his answer to Wesuontup's charges. He told the men with scorn that "he came yeaterday about the Sun two houres past mid day, unto William Carpenter's house at Pawtuxite, and fro' thence he went unto Paswonquitte with Saconocitts sonne and there he st[ayed] all night. That he did not see Wesuntop as he thinckes these 20 days but whereabouts being at worke at J. Coles."

Nanheggen even told the men that he had wanted to offer Wesuontup "wompum to worke" at Mr. Coles, but the farmer would not have him "because he had the name of a thief" and he had not seen him since. He further asserted that as "for the Robery he neither knewe nor heard of it."

Placed together for examination face to face, Wesuontup "charged unto the face of Nanheggen all the particulars of his foresaid charge." Nanheggen "replyed O' Base, with nothing else material to cleare the Charge."

The determination of the "Examinents" was to continue to hold Wesuontup and to commit Nanheggen as well "unto the safe custody of Towne Seargent Hugh Bewitt."

The town then ordered that those selected to be jurors were to "be warne[d] upon service for the Tryall of these Indians Committed." Nicholas Power, Matthew Waller, William Hawkings, Nathanial Dixking, Thomas. Clements and James Aston were chosen to serve as jury. The town further appointed William Field, William Wickenden, Joseph Field, Richard Waterman, Thomas Angell and Thomas Hopkins to serve as well. This case served largely to entice the town to compose a set of laws dealing with "strangers."

Just a few years later, it was ordained that "it shall be lawful for any stranger" to be arrested by "any person or persons when they can apprehend him, and that they shall be tried in the Towne wher[e] they are arrested."[117]

Other inquiries came when any death occured in the colony. One of the earliest found on record is that upon the death of the unfortunate Margaret Goodwin, mentioned earlier, whom jurors determined on March 4, 1657, was killed either by the "terribleness of the crack of thunder on the second of the third month" or the cold, since she was elderly and impoverished after the death of her husband six years earlier.

On August 15, 1679, a jury to serve as a coroner's inquest was summoned to the home of Ephriam and Hannah Pearce to investigate the death of their daughter, Elizabeth Pearce. Neighbor Mehitteble Sprauge testified that "upon ocation of being…at the house of Ephraim pearce, and goeing home from thence homeward a little before the setting of the sun, hearing a sudden nooyse, looked about, and Saw Hannah pearce y' wife of Ephraim Run doune the Hill to y' well and there pulled out Elizabeth."

The witness returned at once to the house where she found that Hannah "had layd her sayd Daughter on ye Bedd, where this deponant sayeth to ye best of her understanding she found sayd Elizabeth pearce…aged about one yeare and a halfe to be Absolutly Dedd…sayd mother of ye sayd Childe did use what meanes they could to preserve life; but it Could not be for ye Childe as aforesd was Dedd."

Hannah Pearce testified that Elizabeth had gone out of the house with her elder sister and that she could hear the children talking outside. About half an hour later, the elder sister returned without her and Hannah "then

Old well in the woods in Putnam, Connecticut. *Photo by author.*

asked the sayd Childe where is your sister, she Answered, shee is gone doune that way, (which way led to ye well, and pond)."

Assistant John Whipple recorded that "wee find that Eliazabeth Pearce the Daughter of Ephraim and Hanah his wife…Exadentally fell into the well, and was overwhelmed in water, and by the providence of God drowned."[118]

Investigating childhood fatalities would be all too commonplace and certainly no less sobering, as when a jury was sent to investigate the sudden death of the young son of Lieutenant James Olney and his wife, Halelujah, which they determined to be "a natural death," or when the twelve men were sent to the scene of a sudden death on the farm of Josiah Owen in late December 1723, when Owen's son "was found dead this present day: the verdict of this jury is that said Josiah Owen was killed accidentally by meanes of Josiah Owen Senior his carte whele running over his head."

In December 1708, the General Court heard the verdict of the jury regarding "a true and due inquest upon ye body of William Carpenter."

Pawtuxet Falls in Pawtuxet, Rhode Island. *Photo by author.*

Carpenter was a member of one of the founding families of Providence. The thirteen-member jury, which included Israel Arnold, Benjamin Carpenter and Nathanial Waterman Jr., found that "upon ye 29th of October the sd William Carpenter in endeavoring to goe over ye river a little above Pawtuxett Falls was by casualty or accident driven downe the Falls by which he was Dashed, Bruised, and Drownded; & so he came by his death."[119]

Jurors were also sent to serve in the General Court, and among the documents of early Providence are those notices summoning the assigned jurors to courts in Portsmouth and Newport: "By virtue of a warante; Received from the Pr[e]sidente to this purpose: this is to will & require you; in his Maijesties name…to choose out of your free inhabittantes soe many: just; able; & honest men; of good reports; as may serve the grand inquest according to law."

Rhode Island had established a precedent for colonial law, not only by a self-governing system of justice but also by its charter, which tolerated the integration of laws representing the citizens' concerns. By contrast, Massachusetts would not have such an opportunity until a new charter was granted in 1692, which began the first dismantling of Puritan authority. The charter incorporated the colony of Plymouth into that of

Old Newport Courthouse. *From Field's* State of Rhode Island and Providence Plantations at the End of the Century *(1901)*.

the Massachusetts Bay Colony, under one royal governor and "a great and Generall Court of Assembly."

The judiciary was placed under a three-tiered structure, composed of a General Court, county courts and individual magistrates. Legal historian Scott Douglas Gerber explains that unlike in Rhode Island, however, the governor

> *with the advice and consent of the council, appointed "Judges, Commissioners of Oyer and Terminer, Sheriffs, Provosts, Marshalls, Justices of the Peace, and other Officers" to Courts of Justice. The general court was afforded "full power and authority to Erect and, Constitute Judicatories and Courts of Record or other Court to be held in the name of the crown."*[120]

Superior Court justices rode circuit through the commonwealth, presiding over all trials of capital crimes and appeals of county court decisions. The county courts were made up of appointed justices of the peace, who sat quarterly in "shire towns" of their own counties to hear complaints of the Court of Common Pleas, and the Court of General Sessions of the Peace.[121]

Samuel Sewall was one of those Superior Court justices, riding circuit through the colony, and he served in Salem in 1692, during the period of the notorious trials of those accused of witchcraft.

Providence's Old Colony House. *Photo by author.*

What was apparent early in the eighteenth century throughout the colonies was the success of the county judiciary with the willingness of inhabitants to bring their grievances into court, thus taking the law in their own hands not by violence, as often occurred before, but within the established legal system.

As Peter Charles Hoffer observes in his *Law and People in Colonial America*:

> *Throughout their Colonial and Revolutionary experience, Americans developed a passion for law, a legalism that pervaded social, economic, and political relationships. They laid their disputes with one another before the courts to an extent exceeding all other peoples. The colonists believed in the possibilities of a lawful world, and their demands for legal redress grew from and sustained this faith.*[122]

In Rhode Island, during the closing decades of the seventeenth century, we find intermingled among the ever-present indictments against fornicators and adulterers those charges brought by citizens against fellow inhabitants for debts owed, grievances unresolved and theft. A few gleanings from the records of the Court of Trials illustrate this development.

In October 1687, John Easton Jr. of Newport brought neighbors Jubash Cottsail and James Thornton into the General Court "for felonious robbering away" of sheep "out of the custody" of his farm. The men were convicted and ordered to pay a fine of forty shillings and to "repay" John Easton Jr. "two good sheep."

On the same docket, Charles Hill was accused of "harboring away sheep which were the proper estate of…Caleb Carr, and Capt. John Fenner." Hill was found guilty and fined forty shillings as well as to repay the farmers "five good sheep." It is notable that during this period, it was common for citizens to come forward before the town council to declare any stray livestock found, setting an agreed period of time for the owner to come forward before ownership was conferred to the claimant.

Within the *Early Records of the Town of Providence* during the period between 1677 and 1750, we find that there were seventy-three such records of "cattle taken up estray" and ninety-three of stray horses. The cases filed against those who added stray livestock to their own herd of cattle or stable of horses was nearly three times that of those who legitimately declared found animals before the council.

Hoffer shows that throughout the colonies, litigation increased significantly in the first decades of the eighteenth century. "By 1730, the rate of lawsuits per thousand people had leapt to three times the level of 1700" in the Massachusetts Superior Court of Judicature. In the town of Plymouth's Court of Common Pleas, cases jumped from 16 lawsuits just after the turn of the century to 385 in the same period. A similar rise in citizen-based litigation occurred in the towns of Gloucester and Marblehead.[123]

This rise in litigation corresponded with the marked increase in trade and commerce through the colonies during this period. Indeed, the majority of cases were debt litigation, as "a larger and larger number of disputes over commerce turned into formal lawsuits." This period also brought about a slow change in the moral code of civil life, with many still living in the shadow of the Puritan courts and others testing the boundaries of the law. This transition resulted in increased litigation as well for personal disputes, or "unjust molestation." It can be argued that this also signaled the growing trust citizens felt that grievances lain before the legal system had a fair measure of success. As Hoffer notes:

> *At the heart of a lawsuit is a sense of wronged dignity, of damaged personal self-worth. One stops disputing and starts suing when one believes that one's opponent denigrates one's credibility and diminishes one's status*

in the community. Dignity is social: the mirror the community holds up to men and women, in which they see their personal value.[124]

Such was the rise in litigation that the fees for filing such grievances rose precipitously and ultimately excluded some, especially women, from claiming debts owed to them or lack of payment for services. Industrious women from the beginning of the colonial period operated an interdependent group of services from wooling, knitting, carding and sewing to clothing repairs, household services and midwifery.

Collecting debts for goods and services was seemingly difficult enough within the male-dominated economy of colonial commerce, if the letters of James Brown of Providence are testimony to what he and other merchants experienced.

In the end, a woman had little voice in court unless responding to a complaint against her person. This was true even in Rhode Island, which had tolerated the outspoken Anne Hutchinson and other independent women. In the court records of the colony for the years between 1662 and 1670, only three cases brought by women were presented before the General Court.

At a hearing in Warwick in October 1662, Ann Elton of Portsmouth brought complaint against Peter Tallman of Newport, who, in her deposition, "hath obtaynede in[to] his handes Craftyly: the substance and goods of Ann Elton."[125]

In September 1664, Mrs. Katherin Milles filed an action of slander and defamation against Ralph Earll Sr. of Newport, asking the court for £500 in damages. She received £5.

Elizabeth Stevens of Newport told the General Court in October 1668 that "she is and stands in feare of her life of her sayd Husband Henry Stevens and desires Reliefe." The Courts sentence was that Mr. Stevens be bound to a bond of £20 and to "be peaceable and good behavior unto All...and more Especially to Elizabeth his wife."[126]

Comparatively, the complaints of fornication and adultery against women and their partners were over twenty in the period between 1671 and 1677, with a dozen complaints in the latter year alone.

Similar to other colonies, what drove the Rhode Island courts into the next century and eventual reforms were those cases protecting property and commerce.

In the decades between 1671 and 1712, the General Court would hear another 59 cases of fornication or adultery but, in the same period, rule on

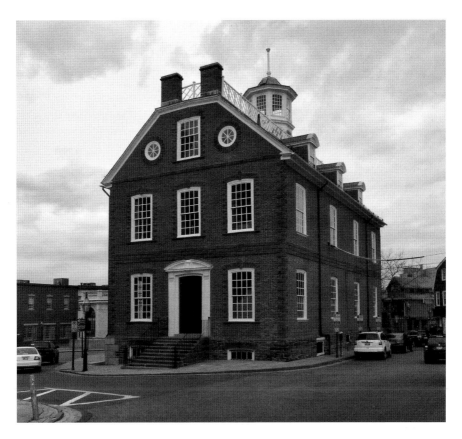

Colony House (1739), in Newport, Rhode Island. *Photo by author.*

approximately 150 actions against debt or damages and another eighty-six cases having to do with trespass or theft.

Amid these and other cases of stolen sheep and horses, trespass on property claims (often the act of letting one's livestock graze free-range, as the expression has it now), suits of slander and those seeking restitution for fraud or debt lie the stories of ordinary citizens, just beginning the bare-knuckled effort to improve themselves in the growing colony. The use of the courts in settling disputes and those said citizens, for the most part, abiding by the jurors' decisions did much to stabilize New England society and allow the growth and resultant prosperity that came in the first decades of the eighteenth century.

Chapter 6

"A GREAT AND GENERALL AWAKENING"

With the prosperity that came into the colonies also came concern from the clergy that Americans were preoccupied with property and material goods rather than spiritual matters. These concerns appeared in jeremiads from pulpits in New England communities and in person in the form of Evangelical ministers who stepped on America's shore and stirred the population in "a great and generall awakening."

The dawn of this awakening began two decades earlier when some Calvinist ministers, most notably William Brattle and Benjamin Wadsworth of Boston, began to preach sermons that emphasized religious tolerance, as well as offering a more hopeful view of faith. Their sermons presented a more benevolent God than Puritan ministers had portrayed and a natural order that was his greatest mystery. Benjamin Kent asserted that the act of committing good works was a possible path to heaven, opening the door for his followers that had long been closed by the doctrine of predestination.

Congregationalist preachers also fought for reform in church doctrine during the 1730s, but nearly all were admonished by elders for questioning long-standing beliefs, and nearly all were forced from the pulpit.[127]

As historian Catherine A. Brekus points out, "The number of Liberal-minded pastors remained small, but the mere fact of their existence was cause for scandal."

Puritan ministers lamented that young people were leaving the faith as they became more educated and began reading works of European philosophers and theologians of other faiths. They were drawn to the treatises of John

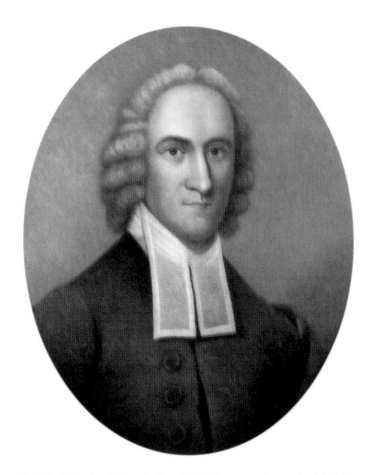

Portrait of Jonathan Edwards. *From Elliot's* History of New England, Vol. 2.

Locke, Francis Hutchinson and others who expanded the role of the self and questioned the doctrine of original sin. John Tillotson, who served as the archbishop of Canterbury in the last decades of the seventeenth century, found fame after his demise on the shelves of these young scholars drawn to his published sermons, whose emphasis on personal morals appealed to those driven to good works in the community.

In the wake of these turmoils, minister Jonathan Edwards noticed a change among the young people in his town of Northampton, Massachusetts. They attended church services on a more regular basis, forgoing those vices of drinking and gaming that had been among the chief recreational pastimes. They debated the doctrinal disputes within

the church and sought Edwards's personal council on matters of moral as well as spiritual questions.

Following a period when the death of several well-known inhabitants seemed to cast a pallor over the town, Edwards would recall:

> *a great and earnest Concern about the great things of Religion…became universal in all parts of the Town…There was scarcely a Person…either old or young, that was left unconcerned about the great Things of the eternal World. Those that were wont to be the vainest, and loosest, and those that had been most disposed to think, and speak lightly of vital and experimental Religion, were now generally subject to great awakenings. And the work of Conversion was carried on in a most astonishing manner, and increased more and more; Souls did as it were come by Flocks to Jesus Christ. From Day to Day, for many Months together…the number of true Saints multiplied, soon made a glorious Alteration in the Town; so that the spring and summer following, Anno 1735, the Town seemed to be full of the Presence of God.*[128]

The awakening spread to South Hadley and other neighboring towns for several more months before "the Spirit of God…appear'd very sensibly withdrawing from all parts of the County; (tho' we have heard of it going on in some Places of Connecticut, and that it continues to be carried on even to this Day.)"

Writing his pamphlet in 1736, Edwards observed, "I know of not one young Person in the Town that has returned to their former ways of Looseness and Extravagancy in any respect; but we still remain a reformed People, and God has evidently made us a new People."[129]

It was a time of social change as well. The burgeoning growth of the colonies expanded the import of innumerable goods and articles that would have been extravagant in a Puritan household. Brekus notes:

> *Economically, a consumer revolution made it possible for people throughout the colonies to buy a greater variety of British goods than ever before, enabling them to make more extensive choices about their everyday lives: what to eat and drink, what to wear, what books to read, and how to decorate their houses. Shopkeepers in cities and villages and peddlers in the countryside offered so many tempting wares for sale that in 1740 a Boston physician punned that the colonies were suffering from a bad case of "Galloping Consumption."*[130]

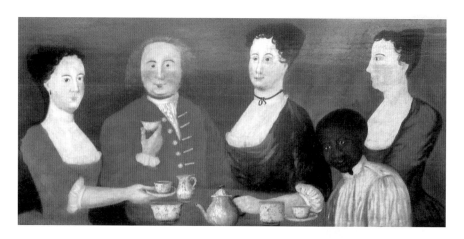

Portrait of the Potter family of North Kingston, Rhode Island, circa 1740. *Courtesy of the Newport Historical Society.*

It was also a time of precipitous growth of slavery in New England. While slaves in the southern colonies worked on large plantations and lived in the shacks constructed by their masters, northern slaves lived with families in the same house, usually given rooms in the attic or the basement, and slaved on farms in the rural areas or as domestic slaves in urban communities. In this growing consumer society of colonial New England, the number of slaves one owned was a symbol of status, as might be the carriage that carried one through town or the dinner and glassware laid for guests on the table.

Brekus makes the point that this growth in goods and status changed the fundamental manner in which New Englanders began to look at themselves beyond the shadow of the years of Puritan authority:

> *Proud of their ability to influence political decisions, to improve the material quality of their lives, to make consumer choices, and to own slaves, growing numbers of Anglo-Americans found it hard to believe the things the Calvinist tradition taught them. They did not feel helpless, but capable. Not weak, but strong. Not sinful, but worthy of the material goods that filled their parlors and the slaves who toiled in their fields.*[131]

These young people of New England were also envisioning a future beyond hardship and war for the first time since settlement began, and that may have contributed to those seeking a moral compass. Edwards's account was circulated throughout the colonies as well as abroad. For many in

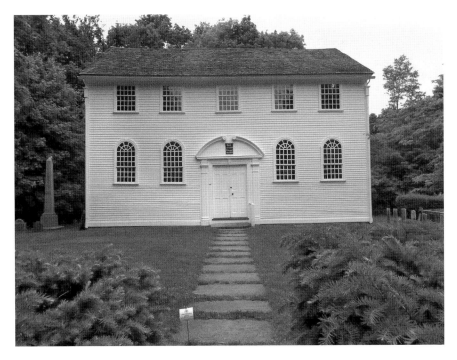

The Old Narragansett Church (1707), the Anglican meetinghouse of the Narragansett planters, moved to its present location in Wickford in 1800. *Photo by author.*

America, that moral compass that would guide them seemed to come with the arrival of Anglican missionary George Whitefield.

Whitefield had crossed the Atlantic in 1738 with little impact, but on his return to London, his fame began to increase. A second tour of the colonies, begun in the fall of 1739, was to last until the following January and would take him to all the major cities in the mid-Atlantic and then down to the South before heading north to New England. Newspapers reported the great crowds the evangelist was drawing, at times in what must have seemed to be astonishing numbers.

In the days before he left for America, he had preached to fifty thousand in London, and in the colonies, a crowd of six thousand had gathered on the Philadelphia common to hear him speak.[132]

As a young man, Whitefield had considered a career in the theater, and it was no doubt these dramatic skills that increased his effect on people. Benjamin Franklin, whose newspapers published numerous accounts of the ministers meetings, would write, "He had a loud and clear voice, and articulated his words perfectly that he might be heard at a great distance."[133]

Indeed, Whitefield was often more at home in a large field than a meetinghouse, and this movement away from the physical restraints of the church was itself a liberating aspect of the awakening.

Among those who gathered to hear the minister preach, a fundamental change in faith seemed to be occurring. Whitefield's sermons made it clear that the path to heaven was open to any person, no matter how great or insignificant they might be on this earth—all were equal in God's eyes. Faith was "the only wedding garment Christ required," and one need only

Trinity Church, Newport, Rhode Island. *Photo by author.*

to "seek the Lord" and commit to follow His laws and teachings to have everlasting life.

Accounts told of the swell of emotions the evangelist was able to stir within the crowds: the throngs of people weeping copiously and the on-site conversions that occurred, with those affected rolling on the ground as though fighting the demons attempting to hold them back from grace.

On his arrival in Newport in 1740, he attracted three thousand at Trinity Church, with nearly a third following him to his lodgings. In the wake of the evangelist's tour, the awakening continued, much to the alarm of church officials, who bemoaned the theatrical outdoor "meetings" and, in Daniel Horsmaden's words, the flock of "vagrant, strolling preachers" who traveled throughout the region. Historian Peter Charles Hoffer evokes the change this wrought on the once-staid communities:

> *Within a town, and from town to town, the tide of Awakening swelled on a sea of words. "Talk of Religion" replaced the everyday, the licentious, and the dull among worldly concerns…The traditional site of preaching was the meetinghouse, now it was the fields. The scale of preaching had exploded, from the congregation to the crowd, sometimes numbering in the thousands.*[134]

Carl Bridenbaugh had also written of the gatherings that "represented every class and condition of the colonists: The Gentleman and the indentured servant, the black slave from Africa, the palatine who understood not a word of English; some were rich and others were poor, there were soul-starved or merely curious persons; many came from the city, the towns, the farms, or backwoods clearings."[135]

Standing among the crowd were also Native Americans and women, who attended evangelical meetings in large numbers and had been involved with events leading up to the revivals since the first stirrings in Northampton. Many, such as Sarah Osborn of Newport, the subject of historian Christina Brekus's recent work, clung to their Puritan "covenant" with God, and attended church each Sunday but found their faith had paled in the shadow Puritan authority had placed them under.

Miss Osborn had endured a difficult life before Whitefield's arrival, having married at seventeen, become widowed and been left with raising a young son on her own. She attended Whitefield's sermon at Trinity Church and recorded that "God in mercy sent his dear servant here…which something stirred me up."

In the aftermath of Whitefield's visit, she attended sermons by minister Gilbert Tennent, even as she was still debating about whether to leave her family congregation. Like Miss Osborn, women all over the region responded to this new message from the New Lights, and this in itself caused controversy, with church authorities scoffing at the evangelists who set "the women gadding about the streets." Church authorities preferred that women remain in their place at home and be silent in the meetinghouse.

Especially dangerous was minister James Davenport of Long Island, who rode the circuit around New England beginning in 1741. In every community he visited, people "flocked in great crowds" to hear his sermons, which were often punctuated by spontaneous outbursts of praise and joy or bursts of song.

Davenport often exhorted followers to cleanse themselves of those idolized goods and extravagant clothing that colonial gentlemen and women had grown accustomed to collecting. By freeing themselves of these worldly goods, they could begin their conversion in purity and grace. An account of Davenport's visit to one New England town was recorded by Dr. Alexander Hamilton, a Scottish physician and philosopher who was touring the colonies at the time:

> *Sunday, August 26…I went home at 6 o'clock, and Deacon Greene's son came to see me. He entertained me with the history of the behavior of one Davenport, a fanatick preacher there who told his flock in one of his enthusiastic rhapsodies that in order to be saved they ought to burn all their idols. They began this conflagration with a pile of books in the public street, among which were Tillotson's Sermons, Beveridge's Thoughts, Drillincourt on Death, Sherlock, and many other excellent authors, and sung hymns and psalms over the pile while it was burning. They did not stop here, but the women made up a lofty pile of hoop petticoats, silk gowns, short cloaks, cambrick caps, red heeled shoes, fans, necklaces, gloves and other such apparel, and what was merry enough, Davenport's own idol with which he topped the pile, was a pair of old, wore out, plush breaches.*[136]

Other traveling evangelists were less dramatic but attracted large, emotional crowds nonetheless. Eleazer Wheelock toured communities around Boston in 1741 and recorded that he preached to "full assemblies." In Taunton, after a revival meeting on the green, he wrote, "I was forced to break off my sermon before I had done, the outcry was so great."[137]

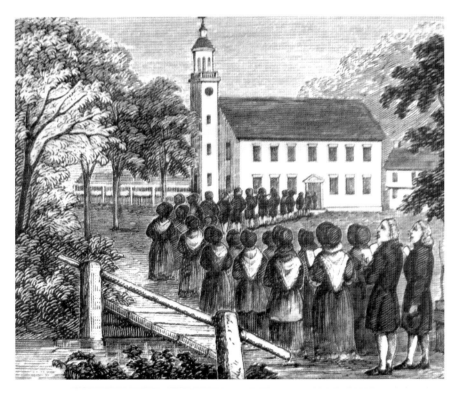

"The Great Awakening" brought visiting New Light preachers to churches in Northampton and other communities in New England. *Courtesy of the Library of Congress.*

Similar outbreaks occurred in revival meetings throughout New England. Reverend James Park, after giving a sermon in Westerly, Rhode Island, wrote to the *Christian History* newspaper that "the wonderful power of god was said to be visibly manifested…several were pricked to the heart, crying out."

Critics of the Great Awakening contended that these emotional outbursts were because followers had begun to be consumed by their own passions. They said these visible signs of torment and crying out were "properly a disease, a sort of madness." One of the most vocal opponents of these revivals was minister Charles Chauncy. A proponent of the theory of passions, he noted of those who flocked to James Davenport's meetings, "A certain wildness is discernable in their general look and air, especially when their imaginations are moved and fired."[138]

Others asserted that the evangelical ministers preyed on the fear of those following their revivals and that the dramatic inflections of the punishments of hell caused the crowd to convulse in an almost supernatural manner.

Gilbert Tennant, whose sermons had attracted considerable numbers, echoed his written words about the damned: "Hear how loudly they roar, how frightfully they screech and tell; how they rage and foam, and gnash their teeth with desperate madness."

Historian Catherine Brekus would write:

> *Although Puritan ministers had always preached about hell, eighteenth-century evangelicals seem to have placed even greater emphasis on its torments. During the excitement of the revivals, many ministers used fear to persuade sinners to repent. In his early sermons Jonathan Edwards had tended to emphasize God's love, but found that he could bring far more converts into the churches by preaching about hellfire.*[139]

Edwards had supported the revivals, convinced like many other ministers of the genuineness of the conversions they had witnessed, but even in writing after the earlier throes of spirituality in his own community, he had sounded a cautionary note: "Lukewarmness in Religion is abominable, and zeal an excellent Grace, yet above all other Christian Vertues, it needs to be strictly watched and searched, for tis that with which Corruption and particularly Pride and human Passion is exceeding apt to mix unobserved."

At the time of his visit to the parish in Enfield, Connecticut, which had remained unaffected by the revival sweeping around it, Edwards chose to emphasize the consequences of that abomination rather than to criticize the zeal of the followers of those evangelists.

The Quakers, however, looked askance at the behavior in these meetings. In 1748, a Friend in Rhode Island was denied membership because in a meeting at his own house, he allowed it "to be disturbed and broken up by…Wild & Ranting people."[140]

Friend and historian Caroline Hazard says that more than one member was ousted after confessing that he had "joined with them in worship by taking off his Hatt, etc." Still others were expelled as they had become "too far joined into the Religious Sentiments and practices of ye people called New light or Seperates."

As late as 1787, Friends in Narragansett were feeling the effect those evangelists of "dark and erroneous principles" had left among the meetinghouse congregations of Rhode Island. A good number of these followers would establish the Baptist church in Wakefield, Rhode Island, whose meetings were said to be marked by "wild religious fervor" and whose

hymns were "a sort of recitation by the leader, with a refrain taken up by the congregation, and punctuated with sighs and groans."[141]

For some, the enthusiasm and reawakening of faith were not to last. Jonathan Edwards became discouraged and, in his own words, "disgusted" that many in Northampton had returned to their old ways of leisure rather than worship. He became preoccupied for some time with a scandal that had broken out in the town when it was discovered that some of the older boys from the more cultivated families in town were circulating "bad books" among themselves, including a treatise for midwives and *Aristotle's Masterpiece; or, The Secrets of Nature Displayed*, both of which handily illustrated matters of reproduction and pregnancy, resulting in several incidents of churlish behavior toward the young women of the town.[142]

But not all had returned to their sinful ways, there in Northampton or in the other towns through which the revival had swept. Sarah Osborn remained faithful to her conversion and forsook her former friends to live more purely, and though more hardship would befall her, she wrote an inspired story for followers and led prayer meetings at her house in Newport, which became a small revival in and of itself.

By 1744, with many of the colonies embroiled on behalf of the British in King George's War, the revivals in New England had tempered, though tensions between New Lights and the church heightened with the news of Whitefield's return in the fall. Edwards would recall, "Many ministers were more alarmed at his coming, than they would have been by the arrival of a Fleet from France, and they soon began to preach and write against him, to warn people to beware of him, as a most dangerous person."

In the southern colonies, the fire still burned, with circuit evangelists still finding great crowds to preach to, a tradition that would remain from those early meetings into the present day. The aftermath of the revival in the North was literally one of soul searching and, for some, repentance. James Davenport published an apogee of sorts in July 1744, in which he confesses to have been misguided in his zeal and in error to have parted from the "analogy of scripture" that he should have used to instruct his followers.

He wasn't alone. Gilbert Tennant also published a "retraction" in Philadelphia in 1744 that bore the meekest of titles: *The Necessity of Studying to be Quiet and Doing Our Own Business*. If a man who once commanded the attention of thousands to hear his words was reduced to writing what reads like something a punished child might have to write on a blackboard, the pressure must have been great on those who once numbered among the New Lights to retract their previous questioning of doctrine, their openness

to women and slaves among their "outdoor meetings" and, especially, as Davenport felt, the worse sin of "singing with others in the streets."[143]

Despite the humble retreat of these local ministers, the Great Awakening had taken hold of its participants and emboldened them in ways that once experienced were to fundamentally change their lives. Historian Perry Miller asserted that the movement never left but had shifted the nature of belief from the old doctrines for good and presaged an even greater acceptance of what Roger Williams first called "liberty of conscience." Miller would write in *Natures Nation*:

> *After 1750, whole segments of Protestant America…made the fatal break: they have dared to say, or at least to act as though they had said, that the merit of faith is not one whit diminished if a passionate preacher arouses, excites, creates the faith in an opponent. The immensity of the revolution becomes apparent the moment we recognize that it did not come to an end in 1750, that it contained a dynamic that took fifty years to work itself out. After a lull, which can be accounted for by the distraction of the War for Independence, the spiritual revolution again went forward in the Second Great Awakening of 1800. Whitefield on the Boston Common, Edwards at Enfield, the Tennents at the Log College, point the way inevitably toward the first gigantic mass meeting at Cane Ridge in 1801, where some twenty thousand people assembled on August 11 and by night three thousand of them had fallen in a trance on the ground, while hundreds were "jerking, rolling, running, dancing, and barking."*[144]

In the midst of that sixty-year revolution, historian Gary Nash sees the movement as a direct influence on those political gatherings that led to the call for independence.

> *Such forays into political activism, first nourished during the Great Awakening, had a cumulative effect. A sense of their own power grew as their trust in those above them diminished and as their own experience expanded in making decisions, exercising leadership roles, and refuting those who were supposed to be wiser because they were wealthier. Hence, factional politics intensified in the late Colonial period. As never before, members of the lower ranks began to act for and of themselves.*

Many remained outside the realm of the established churches and gravitated to separatist ministers or congregations such as Baptist or Methodist orders that remained open to the pursuit of a personal relationship with Christ through

prayer and worship. Peter Charles Hoffer cites the influence of the awakening in those rallies for liberty that evolved after the stamp act, and tensions with Great Britain rose in the later part of the century. However strained one might find the ideological linkage, the historian writes, "The protest mob of the 1760's and 1770's...was the...heir of the awakened congregation."[145]

Bridenbaugh cites the changes wrought by the religious revolution that would eventually enable the colonies to tread that path toward liberty. The efforts of the Baptist and Congregationalist churches to establish colleges in the colonies led to the eventual population of dozens of county churches with educated ministers. The historian wrote, "Students traveled from all over the colonies to attend colleges...Higher education, by enabling many future leaders to become acquainted in the classroom and to study a common curriculum, was definitely a unifying force."[146]

The continued evolvement of sects that dissented from established religious thinking may also be attributed to being strengthened by the reins loosened by the "awakening" as "First the Quakers, then the Baptists, Presbyterians, and Moravians struggled at different times against constituted ecclesiastical authority with varying degrees of success, but always the dissenting group talked and argued in terms of liberty of conscience."

The prevalence of literacy throughout the colonies and the rapid growth of pamphlets and newspapers in the decades after 1740 placed knowledge and the resultant educated opinions in the hearts of many citizens. The historian points out that though the circulation of local newspapers might be modest, the stories they printed were carried far and wide by mail, stagecoach and packet ship to communities throughout the colonies. He writes, "In this way, the printers in the great towns did more to make the widely separated colonists conscious of common religious, social, and economic interests than any other group, even including the ministers."

The evolvement of printed histories and maps of North America implanted a consciousness of place and time in the colonists' historic imagination. As transportation improved, travel increased along with a growing desire for knowledge about the country in which they lived. Maps and almanacs were bestsellers in coffeehouses and bookshops. Maps were often rendered to be framed and hung on the wall so that the viewer could continually "visualize the country he loved, the relation geographically of one place to another, and their distances apart."[147]

Most importantly, to the historian, was the emergence "as public men of non-political persons whose reputation spread beyond the provinces in which they lived."

Laymen who before had focused solely on their own interests began to diverge from that singular view to one of their surrounding communities and beyond, traveling often and voicing their opinions in public lectures and meetings. The colonists, as Bridenbaugh writes, also had a "genius for forming voluntary associations to further good ends" and were often successful in raising needed monies for one charitable cause or another. Whitefield, while preaching in the Northeast, had secured considerable funding for a charity school in Philadelphia, as well as a Christian orphanage in Ebenezer, Georgia.[148]

Bridenbaugh also cites the devastating fire in Charleston in 1740, which leveled "the most valuable Part of the Town" and destroyed the Friendly Society whose funds were designated for relief from such a catastrophe. Such societies were in every community and often established by immigrants from Scotland, Ireland, Germany and Wales. Accounts in newspapers in Boston and Philadelphia brought thousands of dollars in donations.

It was clear that this new generation of Americans, buoyed by wealth and confidence, was also committed to a Christian benevolence toward those less fortunate: the poor, the needful, the orphaned children of the colonies and the elderly and frail within their own communities.

The colonies had, in a sense, matured in ways that they had resisted before, not only in their acceptance of once opposing religious views but also in this striving to better communities as a whole. The adherence to, and attentive construction of the law created the advent of a new generation of leaders eager to attend to the growth of commerce and culture in a land that was becoming increasingly distant and distinct from its motherland across the sea.

NOTES

CHAPTER 1

1. Edward Winslow, *Mourt's Relation* (Boston: J.K. Wiggens, 1865), 27. A much later unearthing of a Narragansett woman by various hands overseen by Dr. Usher Parsons in 1862 set off a debate as to her identity, based largely on the great number of Dutch trinkets found in her grave.
2. Roger Williams, *A Key into the Language of America*, rev. ed. (Applewood Books, 1997), 128.
3. Kathleen J. Bragdon, *Native People of Southern New England* (Norman: University of Oklahoma Press, 1996), 26.
4. See C. Shipton, *Roger Conant: A Founder of Massachusetts* (Cambridge, MA: Harvard University Press, 1944), 59.
5. Bragdon, *Native People*, 26.
6. Samuel G. Drake, *Old Indian Chronicles* (Boston: Samuel A. Drake, 1867), 24.
7. Ibid., 25.
8. Ibid., 28.
9. Williams, *Language of America*, 7.
10. Edward Johnson, *Wonder-Working Providence of Sions Savior in New England* (New York: C. Scribners, 1910), 17.
11. Ibid., 29.
12. John Easton, *A Relaycion of the Indyan Warre, by Mr. Easton, of Road Isld*, from *Narratives of the Indian Wars 1675–1699* (New York: Charles H. Lincoln, 1913).
13. Jill Lepore, *The Name of War: King Philip's War and the Origins of American Identity* (New York: Random House, 1998), 6.
14. Fisher, *Indian Great Awakening*, 27.

15. Harvey Wish, ed., *The Diary of Samuel Sewall* (New York: Farrar, Straus and Girouz, 1973), 24–25.

16. Thomas H. Hazard, *Recollections of Olden Times* (Newport, RI: John Sanborn, 1879), 44.

17. Eric B. Schultz and Michael J. Tougias, *King Philip's War: The History and Legacy of America's Forgotten Conflict* (Woodstock, VT: Countryman Press, 1999), 129–30.

18. In the aftermath of the war, Alderman earned an income from displaying the hand, preserved in a bucket of rum, to curious travelers in the taverns of the area. For a detailed account of these incidents, see Schultz and Tougias, *King Philip's War,* 287–92.

19. Cotton Mather, *Life of the Reverend John Eliot,* imprint ed. (London: D. Jacques, 1820).

20. Alden T. Vaughn, *New England Frontier: Puritans and Indians, 1620–1675* (Boston: Little, Brown, 1965), 321.

21. William S. Simmons, *Spirit of the New England Tribes* (Hanover, NH: University Press of New England, 1986), 163.

22. Edward R. Snow, *True Tales and Curious Legends; Dramatic Stories from the Yankee Past* (New York: Dodd, Mead, 1969).

23. Edward Winslow would record a white translation of this deity and these "ceremonies" in his journals. His interpretation of Hobomok, or Hobbomoken, as "the devil" would lead generations of historians into a one-sided view of this complex god.

24. See Edward Lodi, *Curious Incidents in King Philip's War* (Middleborough, MA: Rock Village Publishing, 2010), 11–14.

Chapter 2

25. See Morison's footnote in Bradford, *Of Plymouth Plantation,* 79.

26. Letter from Samuel Smith to Ichabod Smith, January 1, 1699, quoted from John Demos, ed., *Remarkable Providences: Readings on Early American History* (Boston: Northeastern University Press, 1991), 54.

27. Field, *Early Records of the Town of Providence,* 1:122.

28. Ibid., 3:110.

29. Ibid., 3:7.

30. William Wood, *New England's Prospect* (London: Thomas Cotes, 1635), 45–46.

31. Increase Mather, *Exhortation,* 179.

32. Winthrop, *Winthrop's Journal: History of New England Vol.* 2:156.

33. The "old Indian Hymn" was published by Thomas Cummock, a Narragansett whose family had joined others in the Indian community of Brothertown, Wisconsin. Christian Indian Thomas Cummok's *Indian Melodies*

contained the song and the traditional story behind the hymn. See Simmons, *Spirit of the New England Tribes,* 70–71 and Fisher, *Indian Great Awakening,* 207.

34. Ibid., 2:346.
35. Hull, "Diary," 206.
36. Ibid., 220.
37. According to Hosmer's footnote, the mill was located on Copp's Hill, opposite Charlestown.
38. Comer, *Diary,* 112.
39. Bradford, *Of Plymouth Plantation,* 192.
40. Ibid., 215.
41. Ibid., 217.
42. Hull, "Diary," 148.
43. Comer, *Diary,* 20.
44. See Jeanne E. Abrams, *Revolutionary Medicine* (New York: New York University Press, 2013), 9–12.
45. Ms. Francis's daughter Sally had died from a "Malignant Sire Throat," and her diary, as do others, attests to the variety of illnesses children faced. I am indebted to Henry A.L. Brown for the excerpts provided.
46. Green, "Diary," 220–21.
47. See James W. Willmarth's introduction to John Comer's diary.
48. Comer, *Diary,* 106–7.
49. *Providence Journal,* "History of Yellow Fever in Providence," September 23, 1878.
50. Field, *Early Records of Providence,* 2:56, 104.
51. Sewall, *Diary,* 53.
52. Comer, *Diary,* 42.
53. Sewall, *Diary,* 177.
54. Comer, *Diary,* 121.

CHAPTER 3

55. Bradford, *Of Plimoth Plantation,* 92.
56. Winthrop, *Journal History of New England,* 67.
57. David Thomas King, "Regionalism in Early American Law," in *The Cambridge History of Law in America, Volume I, Early America (1580–1815)* (Cambridge: Cambridge University Press, 2008), 149.
58. Susan Juster, "Heretics, Blasphemers, and Sabbath Breakers," in *The First Prejudice,* 123–42.
59. See James, *Colonial Rhode Island,* 15.
60. See James Kendall Hosmer's footnote in Winthrop's *Journal History of New England,* Vol. 1, 195.

61. James, *Colonial Rhode Island*, 28.

62. Roger Williams, *The Correspondence of Roger Williams*, ed. Glenn Lafantasie (Providence: Brown University Press, 1988), 215. Prudence and Patience Islands lie adjacent to each other in Narragansett Bay. Williams had assisted Winthrop in the purchase of the island several years before, hence his reference to "your Prudence."

63. James, *Colonial Rhode Island*, 28–29.

64. Ibid., 36–37.

65. Mofford, *The Devil Made Me Do It*, 59.

66. Hull, *Diary*, 188.

67. Meredith Baldwin Weddle, *Walking in the Way of Peace* (Oxford, Oxford University Press, 2001), 100.

68. Mofford, *The Devil Made Me Do It*, 62.

69. Ibid., 64.

70. See *The Correspondence of Roger Williams*, 658.

71. He did, however, come close when he attempted to bring to court John Throckmorton's wife and several others for refusing to acknowledge the authority of the town government, but he desisted, it is believed, so as not to threaten the town's delicate balance between church and state.

72. See James, *Colonial Rhode Island*, 41.

73. See Mofford, *The Devil Made Me Do It*, 64.

74. Ibid., 72.

75. James, *Colonial Rhode Island*, 188.

76. Perry Miller, *Nature's Nation* (Cambridge: Belknap Press, 1967), 51.

77. Bradford, *Of Plymouth Plantation*, 316.

78. Cotton Mather, *The Boston Ebenezer* (Boston: B. Green and J. Allen, 1698).

CHAPTER 4

79. Winthrop, *Journal*, 120.

80. Sewell, *Diary*, 51.

81. Mofford, *The Devil Made Me Do It*, 43.

82. Earle, *Curious Punishments of Bygone Days*, 13.

83. Winthrop, *Journal*, 1:108.

84. Ibid., 45.

85. Earle, *Curious Punishments of Bygone Days*, 32.

86. Ibid., 90.

87. Mofford, *The Devil Made Me Do It*, 74.

88. Ibid., 74.

89. Rhode Island General Court of Trials Record Book, 1:50.

90. Winthrop, *Journal*, 317–18.

91. Rapaport, *Naked Quaker*, 15–17.

92. Mofford, *The Devil Made Me Do It*, 99.

93. Ibid., 100–01.

94. Field, *Early Records of Providence*, 9:43.

95. Rapaport, *Naked Quaker*, 90–91.

96. Mofford, *The Devil Made Me Do It*, 93.

97. Robert Geake, *Historic Taverns of Rhode Island* (Charleston, SC: The History Press, 2012), 60.

98. See Edward Field, *The Colonial Tavern* (Providence, RI: Preston and Rounds, 1897) and Geake, *Historic Taverns* for a more detailed review of the case.

99. Geake, *Historic Taverns*, 58.

100. Field, *Early Records of the Town of Providence*, 2:130.

101. Bradford, *Of Plymouth Plantation*, 234.

102. Winthrop, *Journal History*, 2:229.

103. Hull, *Journal*, 249.

104. See footnote to Comer's entry in his diary dated March 1711. Comer, *Diary*, 16.

105. Mofford, *The Devil Made Me Do It*, 39.

106. Field, *Early Records of Providence*, 8:86–88.

107. Ibid., 8:89.

108. Ibid., 3:162.

109. William Staples, *Annals of the Town of Providence* (Providence, RI: Knowles and Vose, 1843), 179–81.

Chapter 5

110. John Russell Bartlett, ed., *Records of the Colony of Rhode Island and Providence Plantations in New England* (Providence, RI: A. Crawford Greene, 1862), 1:64.

111. According to Staples, up until 1840, the longest serving sergeant in Providence was James Hammond, who resigned from the office in 1830 after serving for twenty-one years. He died less than a year later at the age of eighty-one.

112. Bartlett, *Records of the Colony of Rhode Island*, 150–59.

113. Staples, *Annals of the Town of Providence*, 64–65.

114. Bartlett, *Rhode Island Colonial Records*, 1:159.

115. Ibid., 1:113.

116. Field, *Early Records of the Town of Providence*, 8:26–28.

117. Ibid., 8:86–88.

118. Ibid., 8:195–96.

119. Ibid., 5:253–54.

120. Scott Douglas Gerber, *A Distinct Judicial Power: The Origins of an Independent Judiciary, 1606–1787* (Oxford: Oxford University Press, 2011), 81.

121. Martha McNamara, *From Tavern to Courtroom* (Baltimore, MD: John Hopkins University Press, 2004), 12–13.

122. Hoffer, *Law and People in Colonial America*, 10.

123. Ibid., 50–51.

124. Ibid., 54.

125. *Rhode Island Court Records 1662–1670* (Providence: Rhode Island Historical Society, 1922), 10. Tallman was given a harsh sentence, the court ordering the commissioners to "sease into your hands to the value of 300 lb as also all his negers that are and have bine knowne to be peter Tollmanes since his Comminge into new England…goods moneyes Cattle debts or other Estate you shall aprase until you have seased into your hands unto the value aforesaid that Ann Elton may be satisfied her Just Debt."

126. Ibid., 74.

CHAPTER 6

127. See Brekus, *Sarah Osborn's World*, 25–29 for a succinct summary of the years leading up to the Great Awakening.

128. Jonathan Edwards, "A Faithful Narrative of the Surprising Work of God," from *Writings of the Great Awakening* (New York: Library of America, 2013), 21–22.

129. Ibid., 81.

130. Ibid., 26.

131. Ibid., 28.

132. Brekus, *Sarah Osborn's World*, 120.

133. Benjamin Franklin, *Autobiography* (Philadelphia: University of Pennsylvania Press, 2005), 179.

134. Hoffer, *Sensory Worlds in Early America*, 177.

135. Bridenbaugh, *The Spirit of '76*, 81.

136. Carl Bridenbaugh, ed., *Gentleman's Progress: The Itinerarium of Dr. Alexander Hamilton, 1744* (Pittsburg, PA: University of Pittsburg Press, 1948), 161.

137. See Hoffer, *Sensory Worlds in Early America*, 166–68 for his account of the transformation brought by the awakening to New England.

138. Chauncy, *Enthusiasm Described and Cautioned Against*.

139. Brekus, *Sarah Osborn's World*, 145.

140. Hoffer, *Sensory Worlds in Early America*, 112.

141. Ibid., 182.

142. Ibid., 18.

143. Miller, *Nature's Nation*, 82.

144. Ibid., 83.

145. Hoffer, *Sensory Worlds in Early America*, 188.

146. Bridenbaugh, *The Spirit of '76*, 84.

147. Ibid., 88.

148. Ibid., 89–90.

SELECTED BIBLIOGRAPHY

Beneke, Chris, and Christopher S. Grenda. *The First Prejudice: Religious Tolerance and Intolerance in Early America.* Philadelphia: University of Pennsylvania Press, 2011.

Bradford, William. *Of Plymouth Plantation, 1620–1647.* New York: Knopf, 1952.

Brekus, Catherine A. *Sarah Osborn's World: The Rise of Evangelical Christianity in Early America.* New Haven, CT: Yale University Press, 2013.

Bridenbaugh, Carl. *The Spirit of '76: The Growth of American Patriotism Before Independence, 1607–1776.* New York: Oxford University Press, 1975.

Chauncy, Charles. *Enthusiasm Described & Cautioned Against: A Sermon Preach'd at the Old Brick Meeting House in Boston.* Boston: printed by J. Draper, 1742. From the collection of the John Carter Brown Library at Brown University.

Coleman, John T. *Vicious: Wolves and Men in America.* New Haven, CT: Yale University Press, 2004.

Comer, John. *The Diary of John Comer.* Vol. 3. Providence: Rhode Island Historical Society, 1893. Collections of the Rhode Island Historical Society.

Earle, Alice Morse. *Curious Punishments of Bygone Days.* New York: Macmillan, 1922.

Field, Edward, ed. *Early Records of the Town of Providence.* Vols. 1–8. Providence, RI: City Council of Providence, 1899.

Fisher, Linford. *The Indian Great Awakening.* New York: Oxford University Press, 2011.

Green, Joseph. "Diary of Joseph Green." From *Puritan Personal Writings.* New York: AMS Press, 1983.

Hoffer, Peter Charles. *Law and People in Colonial America.* Baltimore, MD: Johns Hopkins University Press, 1992.

————. *Sensory Worlds in Early America.* Baltimore, MD: Johns Hopkins University Press, 2003.

Hull, John. "Diaries of John Hull." From *Puritan Personal Writings.* New York: AMS Press, 1983.

James, Sydney V. *Colonial Rhode Island: A History.* New York: Charles Scribner & Sons, 1975.

Lafantasie, Glenn, ed. *The Correspondence of Roger Williams.* Vol. 1 and 2. Providence, RI: Historical Society/Brown University Press, 1988.

Mather, Cotton. *Cases of Conscience Concerning Evil Spirits Personating Men, Witchcraft, Infallible Proofs of Guilt.* Boston: B. Harris, 1693. From the collection of the John Carter Brown Library at Brown University.

Mofford, Juliet Haines. *The Devil Made Me Do It: Crime and Punishment in Early New England.* Guilford, CT: Globe Pequot Press, 2012.

Rapaport, Diane. *The Naked Quaker: True Crimes and Controversies from the Courts of Colonial New England.* Boston: Commonwealth Editions, 2007.

Rhode Island Court Records. Vol. 1 and 2. Providence: Rhode Island Historical Society, 1922.

Sewall, Samuel. *The Diary of Samuel Sewall.* Wish, ed. New York: G.P. Putnam, 1967.

Winthrop, John. *Winthrop's Journal History of New England 1630–1649 Original Narratives of Early American History.* Vols. 1 and 2. Edited by J. Franklin Jameson. New York: Scribners, 1908.

INDEX

ABOUT THE AUTHOR

Robert A. Geake is a New England historian and author of seven previous books, including *A History of the Narragansett Tribe of Rhode Island: Keepers of the Bay*, *A History of the Providence River*, *The New England Mariner Tradition* and *Historic Rhode Island Farms*, as well as other titles from The History Press.

He is an associate of the John Carter Brown Library at Brown University and an archivist and

Courtesy of Jesse Geake.

board member of the Warwick Historical Society. Mr. Geake also volunteers as a docent at Smith's Castle on Cocumscussoc, near Wickford, Rhode Island, and serves on its committee for planning educational programs.